BRIDGMANS
LIFE · DRAWING

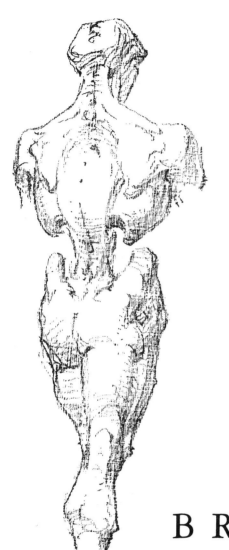

GEORGE B. BRIDGMAN

BRIDGMANS
LIFE , DRAWING

DOVER PUBLICATIONS, INC., NEW YORK

Published in Canada by General Publishing Company, Ltd., 30 Lesmill Road, Don Mills, Toronto, Ontario.

This Dover edition, first published in 1971, is an unabridged and unaltered republication of the work originally published by Bridgman Publishers Inc. in 1924. It is reprinted by special arrangement with Sterling Publishing Company, 419 Park Avenue South, New York City 10016.

Library of Congress Catalog Card Number: 74-182098

International Standard Book Number: 0-486-22710-3

Manufactured in the United States of America
Dover Publications, Inc.
180 Varick Street
New York, N. Y. 10014

To Jean

I wish to express my appreciation and thanks to DOUGLAS HOXSEY SMITH for his cooperation and assistance in the preparation of the text of this book.

GEORGE B. BRIDGMAN

Table of Contents

✠

DRAWING THE FIGURE - - - 11

BUILDING THE FIGURE - - - 15

BALANCE - - - - - 28

RHYTHM - - - - - 34

TURNING OR TWISTING - - - 45

WEDGING, PASSING and LOCKING - 54

DISTRIBUTION OF THE MASSES - - 68

LIGHT AND SHADE - - - 73

MOULDINGS - - - - - 81

PROPORTION
Scientific and Ideal - - - 86

HOW TO MEASURE - - - - 88

MOVABLE MASSES - - - 92

HEAD AND FEATURES
The Head - - - - - 95
The Skull - - - - 97
Drawing the Head - - - - 102
Perspective - - - - 105
Distribution of the Masses - - - 109
Building - - - - - 111
Planes - - - - - 112
Mouldings - - - - 114

Table of Contents (*Continued*)

HEAD AND FEATURES

 Light and Shade - - - - 118

 The Eye - - - - 120

 The Nose - - - - - 122

 The Mouth - - - - 126

 The Ear - - - - - 128

 The Neck - - - - - 130

TORSO — FRONT - - - - 134

ABDOMINAL ARCH - - - 136

THE SHOULDER GIRDLE - - - 140

TORSO — BACK - - - - 142

THE UPPER LIMBS - - - - 148

 The Arm—Front - - - - 150

 The Arm—Back - - - - 152

 The Hand - - - - 154

 Fingers - - - - - 158

LOWER LIMBS - - - - 160

 Thigh and Leg—Front and Side - - - 163

 Thigh and Leg—Back - - - 164

 The Knee - - - - - 166

 The Foot - - - - - 169

Introduction

✤

THIS is the story of the blocked human form where the bending, twisting or turning of volume gives the sensation of movement held together by rhythm. The different stages are arranged in their sequence from How to Draw the Figure to the Balance of Light and Shade. Its purpose is to awaken the sense of research and analysis of the structure hidden beneath. It is hoped that the ideas conveyed in the drawing and text of this book may enable the reader to carry on to independent and better ideas.

DRAWING THE FIGURE

BEFORE you make a line you must have a clear conception of what you want to draw. In your mind it is necessary to have an idea of what the figure to be drawn is doing. Study the model from different angles. Sense the nature and condition of the action, or inaction. This conception is the real beginning of your drawing.

Then, give due consideration to the placing of your drawing on the paper, for balance and arrangement.
Make two marks to indicate the length of the drawing.

Block in with straight lines the outline of the head. Turn it carefully on the neck, marking its center by drawing a line from the Adam's apple to the pit between the collar bones.

From the pit of the neck make one line giving the direction of the shoulders, keeping in mind the marking of its center, which should be the pit between the collar bones.

Indicate the general direction of the body by outlining to the hip and thigh, at its outermost point, the side that carries the weight.

[11]

 Follow this by outlining the opposite in-
active side of the body, comparing the width
with the head.

 Then, crossing again to the action side of
the figure, drop a line to the foot. You
now have determined the balance, or equi-
librium of the figure.

 Carry the line of the inert side to the knee,
over and upward to the middle of the figure.

 On the outer side, drop a line to the other
foot.

These few simple lines place the figure. They give
its general proportions, indicating its active and in-
active sides, its balance, unity and rhythm. Bear in
mind that the head, chest and pelvis are the three
large masses of the body. They are in themselves im-
movable. Think of them as blocks having four sides,
and as such they may be symmetrically placed and
balanced, one directly above the other. In this case,
the figure would have no movement. But when these
masses bend backward, forward, turn or twist, the
shifting of them gives action to the figure. Yet what-
ever positions these three masses may assume, no
matter how violently they may be drawn together on

one side, there is a corresponding gentleness of line on the opposing, inert side and a subtle, illusive, living harmony flowing through the whole, which is the rhythm of the figure.

 Starting again with the head, and thinking of it as a cube with front, sides, top, back and base, draw it on a level with the eye, foreshortened or in perspective.

 Outline the neck and from the pit of the neck draw a line down the center of the chest.

 At a right angle to this line, where stomach and chest join, draw another line and then draw lines to indicate the rib cage as a block, twisted, tilted or straight according to its position.

 Now draw the thigh and the leg which support the greatest part of the weight of the body, making the thigh round, the knee square, the calf of the leg triangular and the ankle square. Then draw the arms.

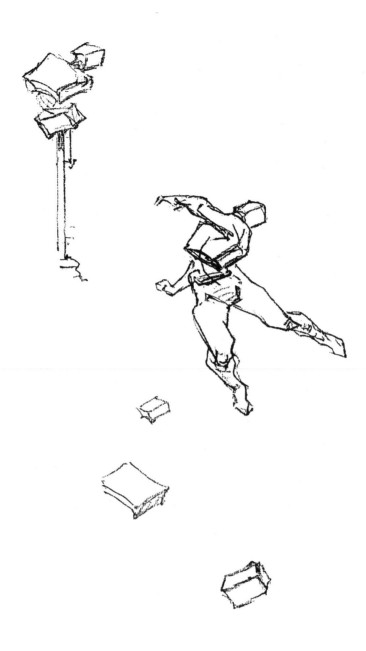

BUILDING THE FIGURE

❦

From a piece of lath and a few inches of copper or other flexible wire, a working model of the solid portions of the body may be constructed. Cut three pieces from the lath to represent the three solid masses of the body: the head, chest and hips. Approximately, the proportions of the three blocks, reduced from the skeleton, should be — Head, 1 inch by ⅝ of an inch; torso, 1½ inches by 1¼ inches; hips, 1 inch by 1¼ inches.

Drive two parallel holes perpendicularly through the center of the thickness of each of these blocks, as closely together as practicable. Wire the blocks together by running a strand of flexible wire through each of these holes, allowing about half an inch between the blocks, and twist the wires together. The wire in a rough way represents the spine or backbone.

The spine is composed of a chain of firm, flexible joints, discs of bone, with shock-absorbing cartilages between them. There are twenty-four bones in the spine, each bending a little to give the required flexibility to the body, but turning and twisting mostly in the free spaces between the head and chest, and between the chest and hips. The spine is the bond of union between the different parts of the body.

The portion of this wire between the head and chest blocks represents the neck. On the neck the head has the power to bend backward and forward, upward and downward, and to turn. The head rests upon the

[15]

uppermost vertebra of the spine, to which it is united by a hinged joint. Upon this joint it moves backward and forward as far as the muscles and ligaments permit. The bone beneath this hinged joint has a projection or point resembling a tooth. This enters a socket or hole in the bone above, and forms a pivot or axle upon which the upper bone and the head, which it supports, turn.

So, when we nod, we use the hinged joint, and when we turn our heads, we use the pivot or axle.

The wire between the two lower blocks represents that portion of the spine which connects the cage or chest above with the basin or pelvis below. This portion of the spine is called the Lumbar region. It rests upon the pelvis or basin into which it is mortised. Its form is semicircular: concave from the front. As the spine passes upward, becoming part of the cage or chest, the ribs are joined to it. On this portion of the spine, the lumbar, depends the rotary movement between the hips and the torso.

The masses of head, chest and pelvis, represented by the three blocks, are in themselves unmoving. Think of these blocks in their relation to each other and forget, at first, any connecting portions other than the slender wire of the spine.

In the little tin soldier at "attention" we have an example of the symmetrical balance of these blocks one directly over the other. But this balance never exists when the body is in action, seldom, indeed, when it is in repose. The blocks in their relation to each other are limited to the three possible planes of movement. They may bend forward and back in the

sagittal plane, twist in the horizontal plane or tilt in the transverse plane. As a rule, all three movements are present and they may be closely approximated by turning and twisting the three blocks in the little model of lath and wire.

The limitation to the movement of the spine limits the movements of the three masses or blocks. Such movement as the spine allows the muscles also allow.

BUILDING

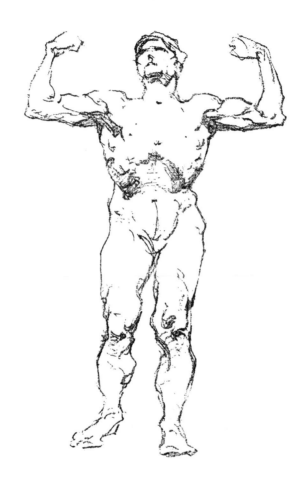

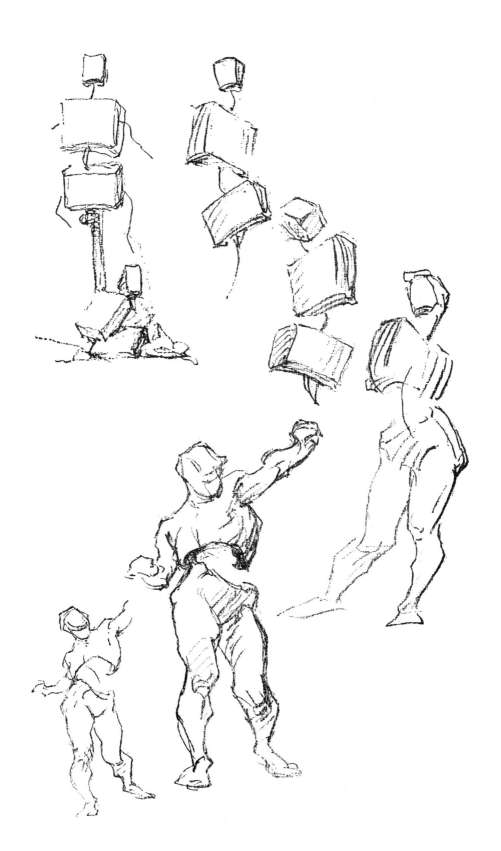

BUILDING

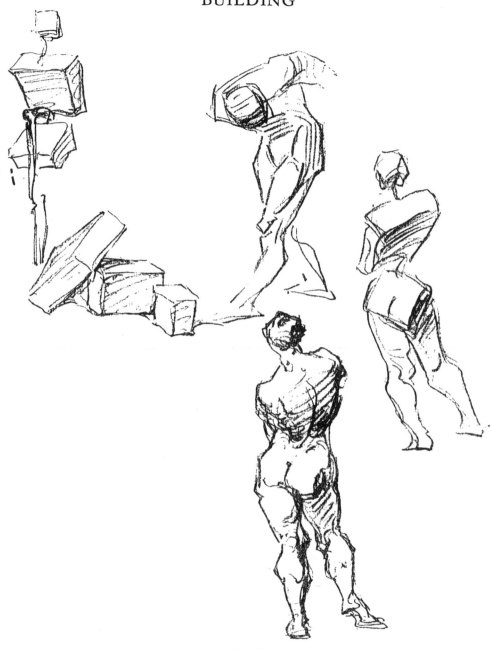

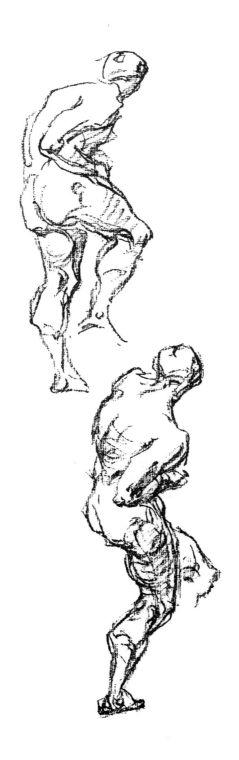

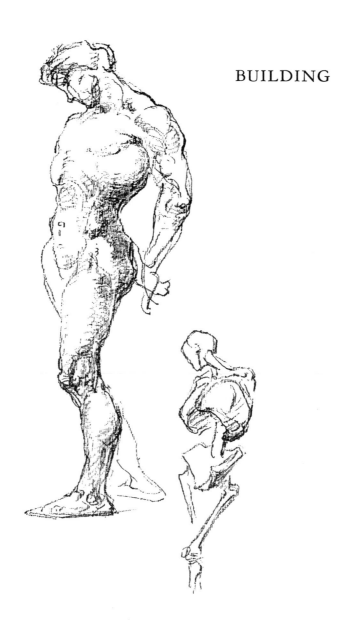

BUILDING

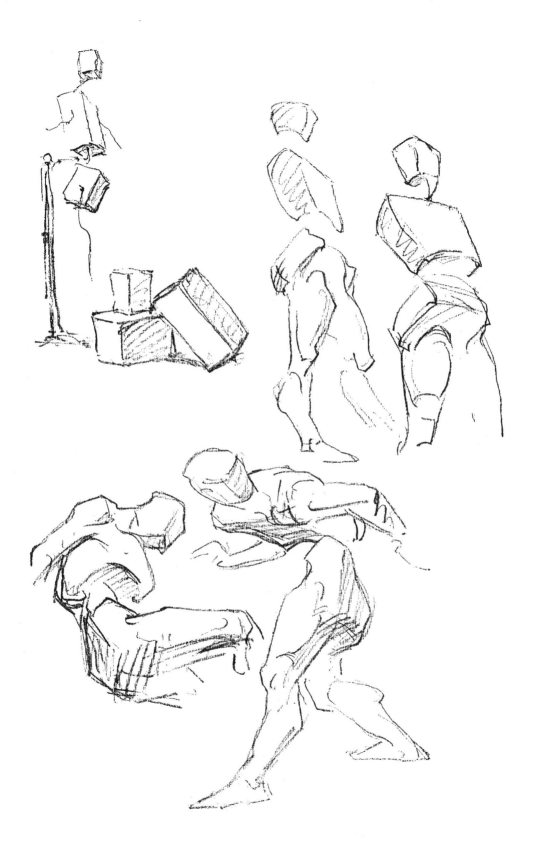

BUILDING

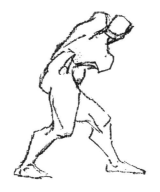

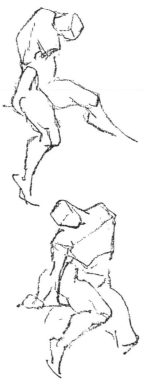

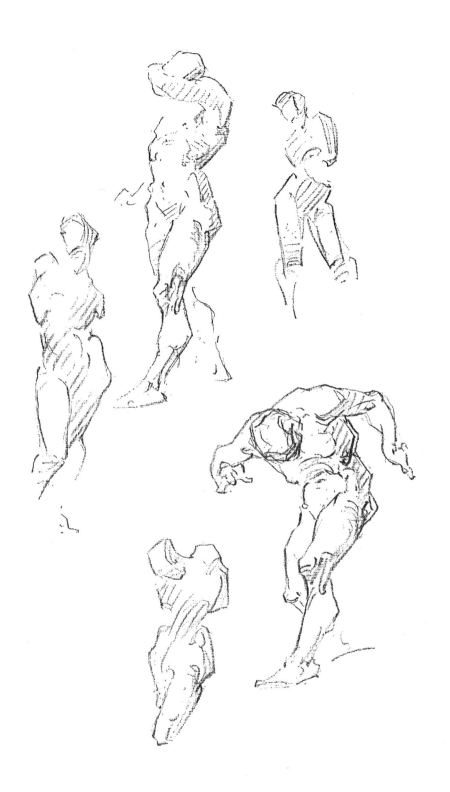

BUILDING

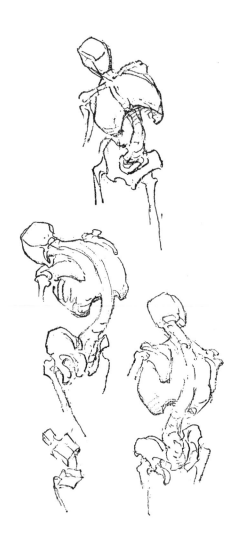

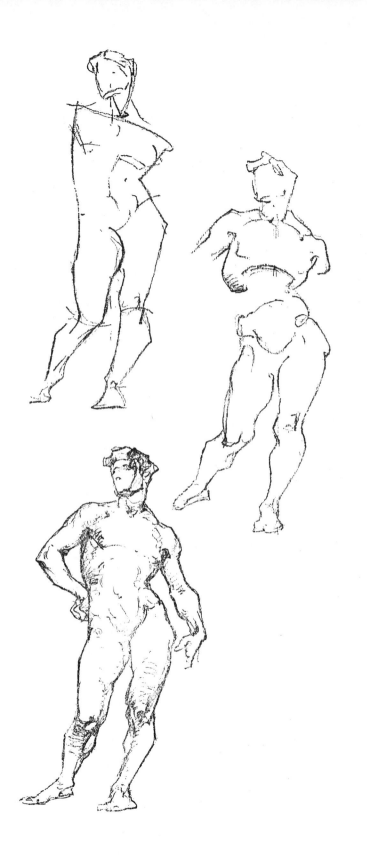

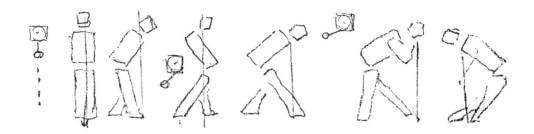

BALANCE

WHEN several objects are balanced at different angles, one above the other, they have a common center of gravity. In a drawing there must be a sense of security, of balance between the opposite or counter-acting forces, regardless of where the center line may fall. This is true no matter what the posture may be. A standing figure whether thrown backward or forward, or to one side or the other, is stationary or static. The center of gravity, from the pit of the neck, passes through the supporting foot or feet, or between the feet when they are supporting the weight equally.

In a way, the pendulum of a clock when hanging straight, or perpendicular, represents a standing figure without movement. It is static, stopped. So is the clock. But start the pendulum swinging. It describes an arc, moving back and forth, but always about a fixed center of gravity. The position of the pendulum when at one or the other extreme of its swing or arc,

from its center of gravity, represents the extent to which a figure may be thrown out of balance. And this position would also represent the greatest rapidity of motion in the drawing of a figure in action. Yet even in the most extreme motion there must be a sense of security, a feeling that the figure, like the pendulum, could come back to a fixed center of gravity. This feeling or sense of balance which must be recorded in the flow or sweep of a drawing is continuity and rhythm.

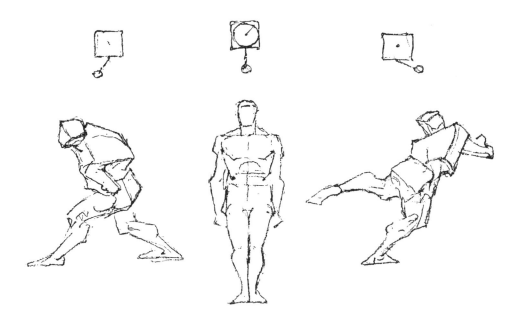

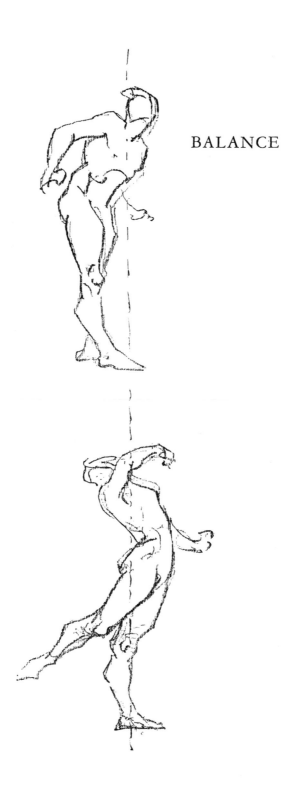

BALANCE

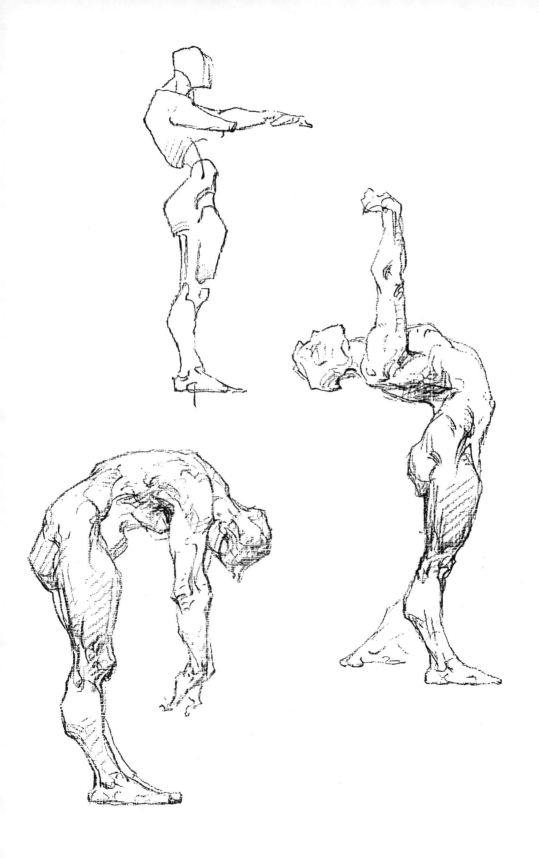

BALANCE

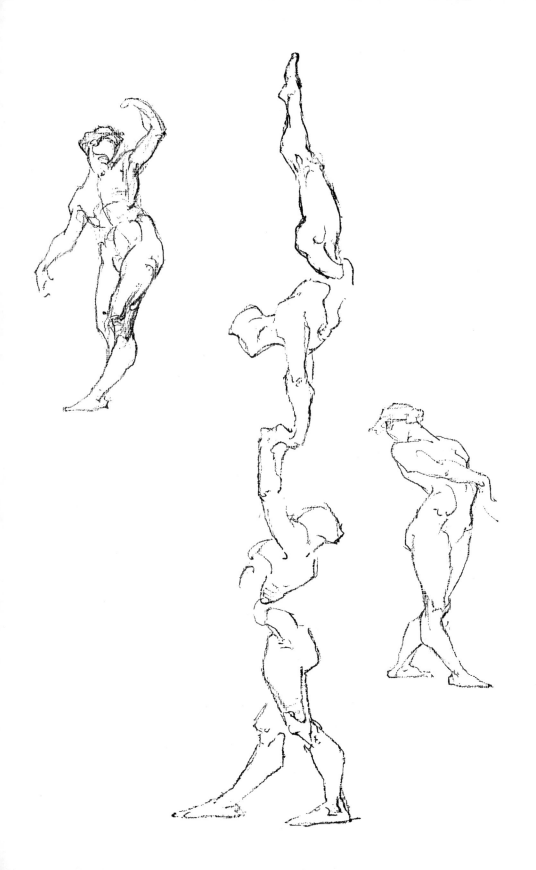

RHYTHM

THE consciousness or idea of rhythm can not be traced to any period, or to any artist or group of artists. We know that in 1349 a group of Florentine artists formed a society for the study of the chemistry of colors, the mathematics of composition, etc., and that among these studies was the science of motion. But rhythm was not invented. It has been the measured motion of the Universe since the beginning of time. There is rhythm in the movement of the sea and tides, stars and planets, trees and grasses, clouds and thistle-down. It is a part of all animal and plant life. It is the movement of uttered words, expressed in their accented and unaccented syllables, and in the group-ing and pauses of speech. Both poetry and music are the embodiment, in appropriate rhythmical sound, of beautiful thought, imagination or emotion. Without rhythm there could be no poetry or music. In draw-ing and painting there is rhythm in outline, color, light and shade.

The slow, continuous moving picture has given us a new appreciation of rhythm in all visible move-

ment. In these pictures of pole vault or steeplechase we actually may follow with the eye the movement of every muscle and note its harmonious relation to the entire action of the man or horse.

So to express rhythm in drawing a figure we have in the balance of masses a subordination of the passive or inactive side to the more forceful and angular side in action, keeping constantly in mind the hidden, subtle flow of symmetry throughout.

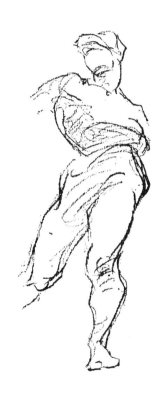

RHYTHM

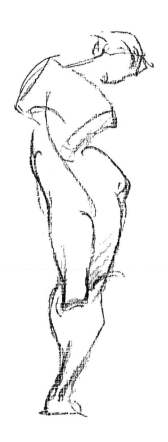

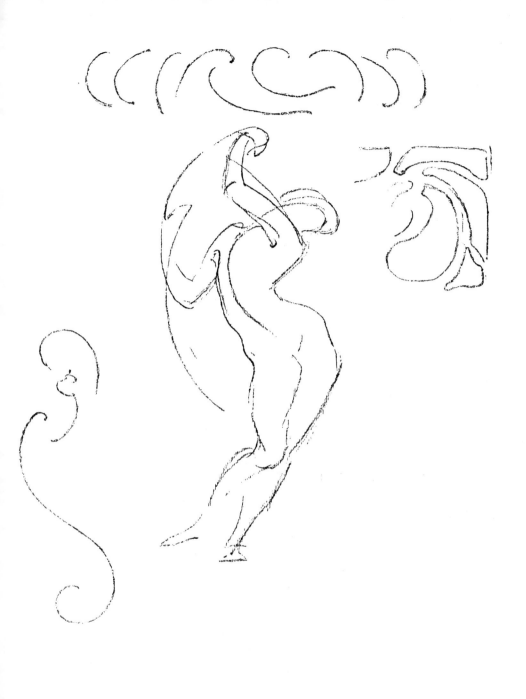

RHYTHM

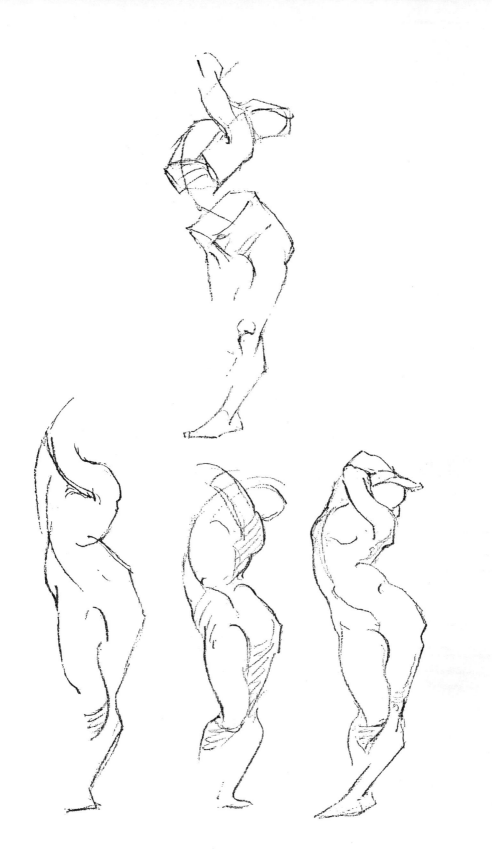

RHYTHM

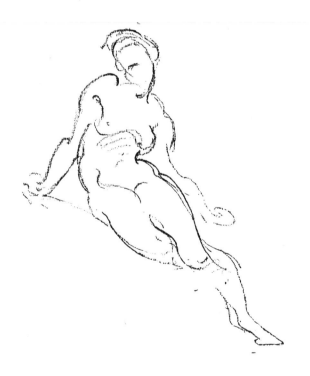

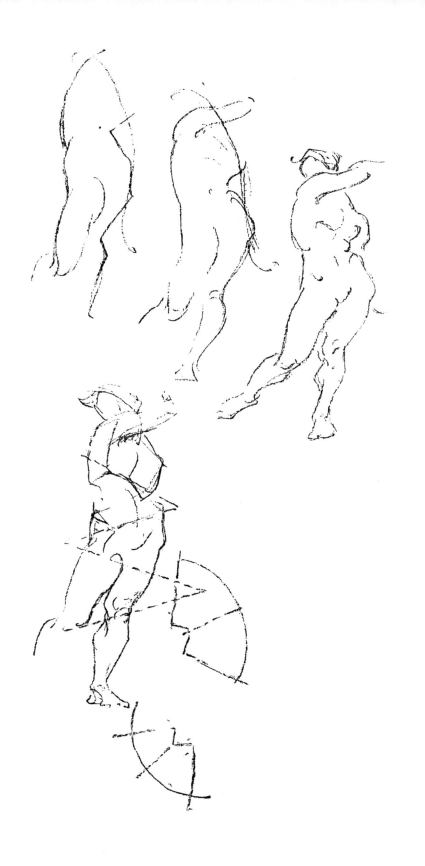

RHYTHM

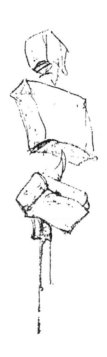

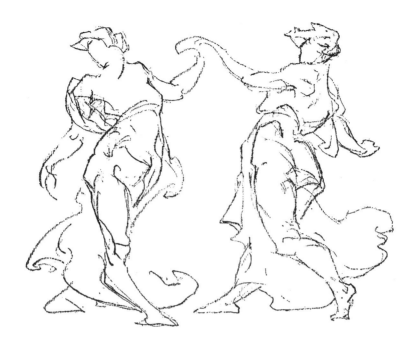

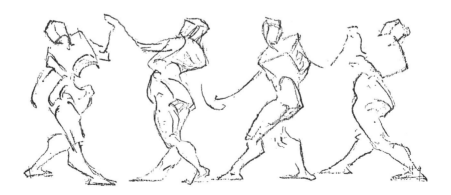

TURNING OR TWISTING

I~N~ a human figure there are the masses of head, chest and pelvis. Each of these has a certain height, breadth and thickness. Considered as blocks, these masses balance, tilt and twist, held together in their different movements by the spinal column. As they twist and turn, the spaces between them become long, short or spiral.

We might liken these movements and the spaces between the masses or blocks, to an accordion when it is being played. Here we have an angular, virile, active side, the result of forcing the ends or forms towards each other and by this action compressing and bringing together on the active side, the pleats of the accordion; the opposite or inflated side describing gentle, inert curves.

The blocks or masses of the body are levers, moved by muscles, tendons and ligaments. The muscles are paired, one pulling against the other. Like two men using a cross-cut saw, the *pulling* muscle is swollen and taut, its companion is flabby and inert. When two or more forms such as the chest and the pelvis are drawn violently together, with cords and muscles tense on the active side, the inert, passive mass opposite must follow. There is always to be considered this affinity of angular and curved, objective and subjective, active and passive muscles. Their association is inevitable in every living thing. Between them, in the twistings and bendings of the body there is a harmony of movement, a subtle continuity of form, ever changing and elusive, that is the very essence of motion.

[45]

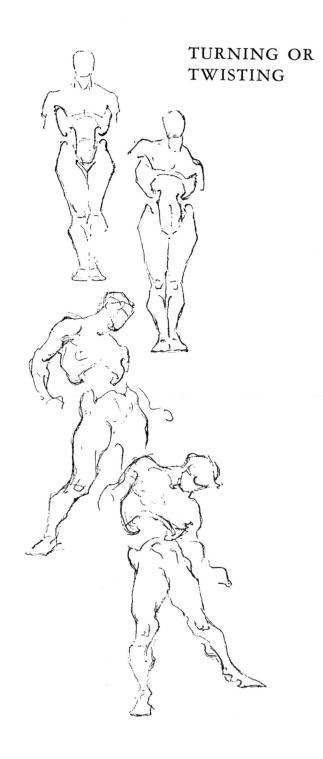

TURNING OR
TWISTING

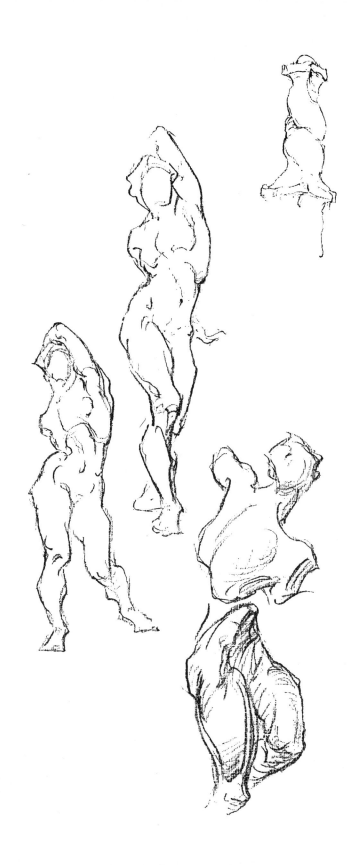

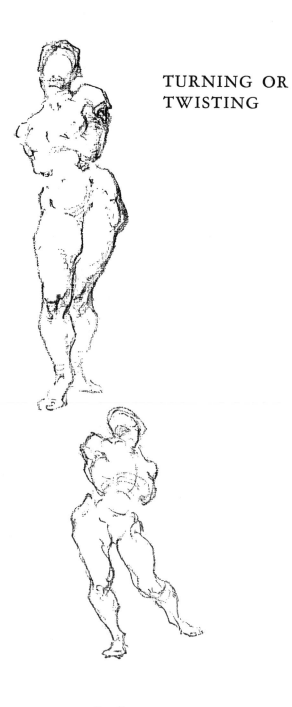

TURNING OR
TWISTING

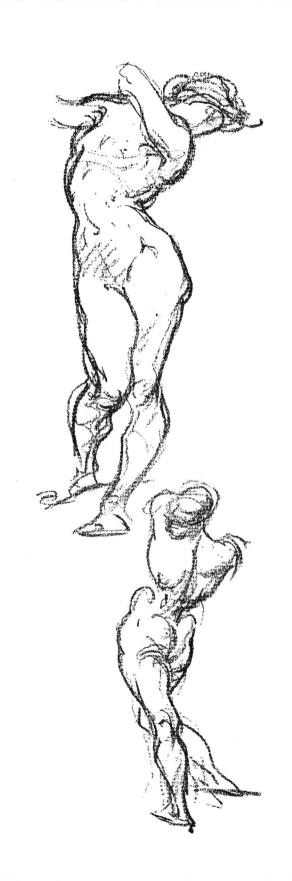

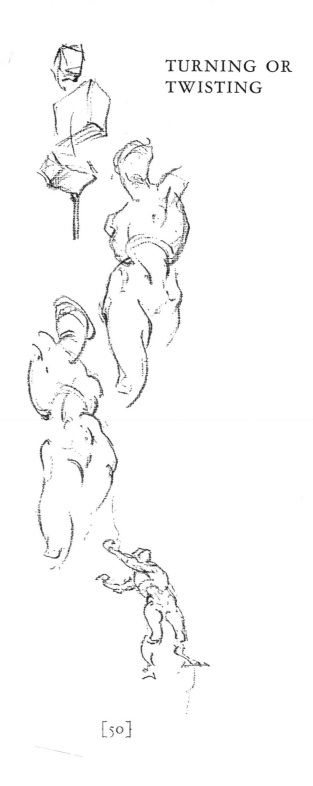

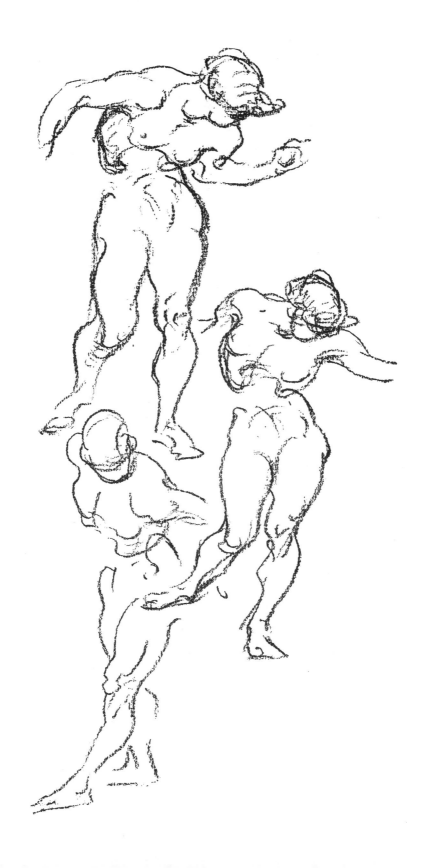

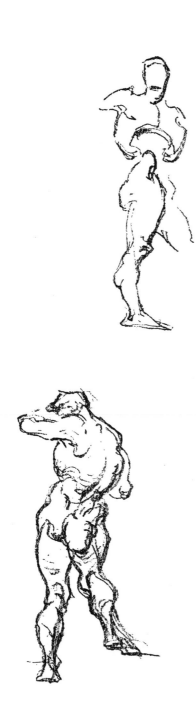
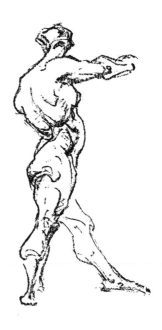

TURNING OR
TWISTING

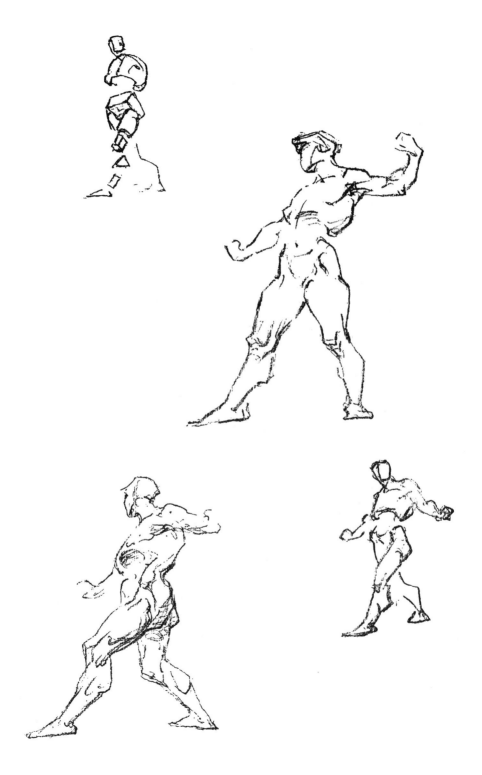

WEDGING, PASSING
& LOCKING

THE upper and lower limbs are held in place on the cage and pelvis by mortise and tenon, called ball-and-socket joint and at elbow and knee by the ginglymus or hinge joint. The surrounding muscles, by their position, shape and size are capable of moving these joints in any manner that the construction of the joints permits.

As movement occurs, and the body instinctively assumes a position suited to the taking of some action, the muscles, by contraction, produce the twisting and bending of the masses. In so doing the muscles themselves expand, shorten and bulge, making smaller wedges or varied forms connecting the larger and more solid masses. This shortening and bulging of the muscles becomes an assemblage of parts that pass into, over and around one another, folding in and spreading out. It is these parts passing into or over each other that gives the sense of wedging or interlocking. This might be compared to the folds in drapery. Where the folds change, their outline changes.

A form either passes around or enters into an outline in more than the visible boundary of a figure. It should be an indication of what it really is: the outline of a form. Within this outline, for the same reason, forms pass into and over other forms. They wedge, mortise and interlock.

[54]

The outline of a figure may be so drawn that it gives no sense of the manifold smaller forms of which it is composed. Again, the outline of a figure may be so drawn that the sense of the figure's depth, of the wedging, interlocking and passing of smaller forms within the larger masses conveys to the mind an impression of volume and solidity.

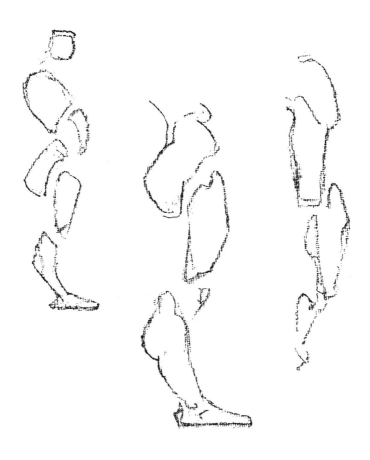

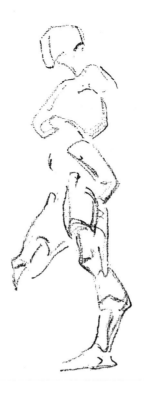

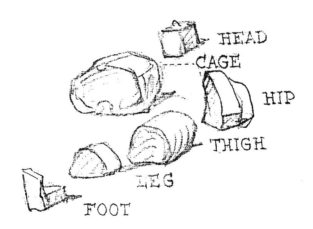

HEAD

CAGE

HIP

THIGH

LEG

FOOT

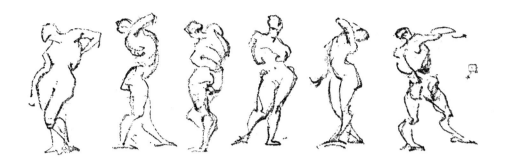

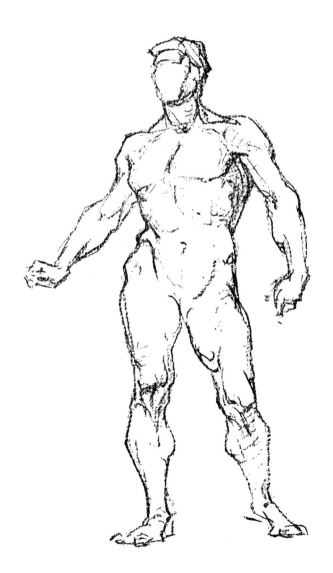

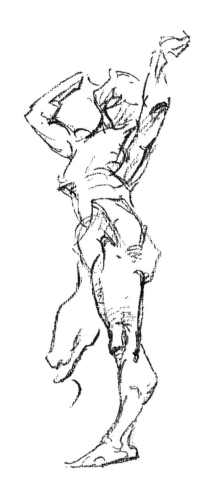

WEDGING, PASSING & LOCKING

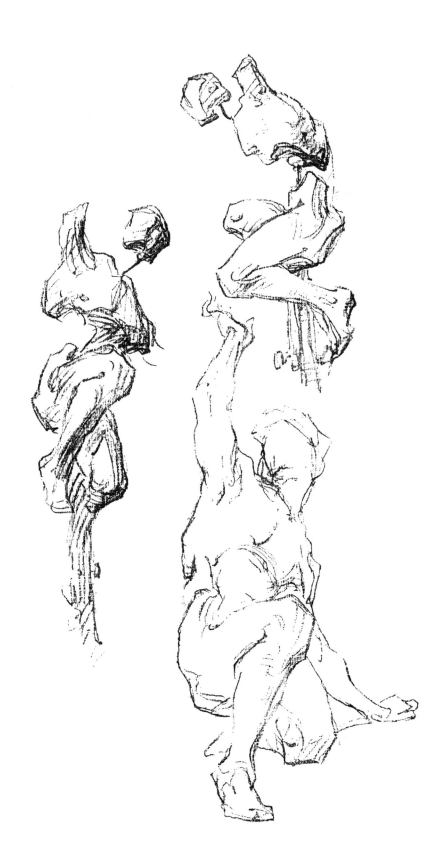

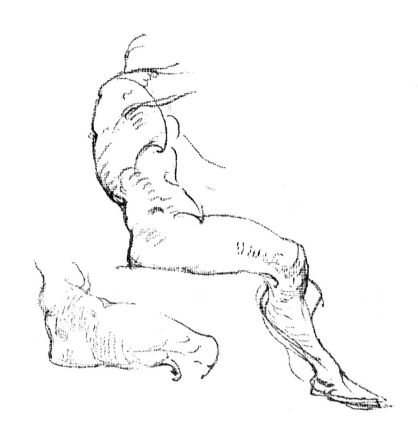

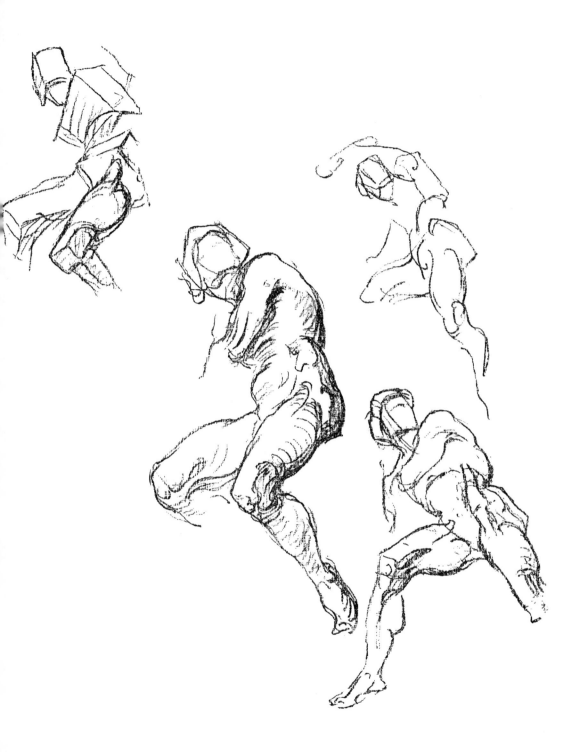

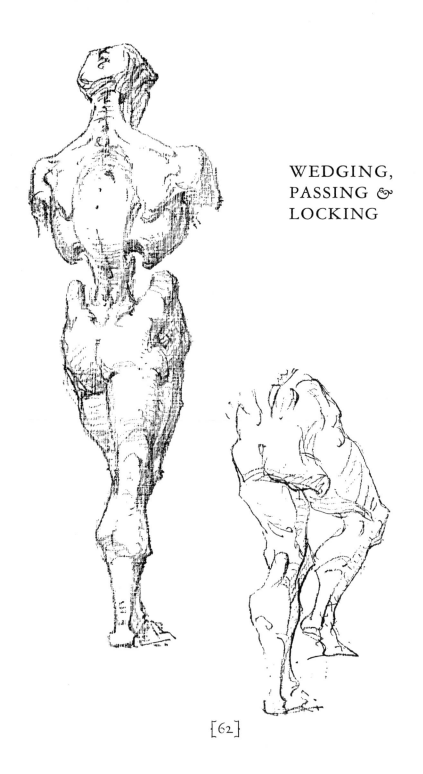

WEDGING,
PASSING &
LOCKING

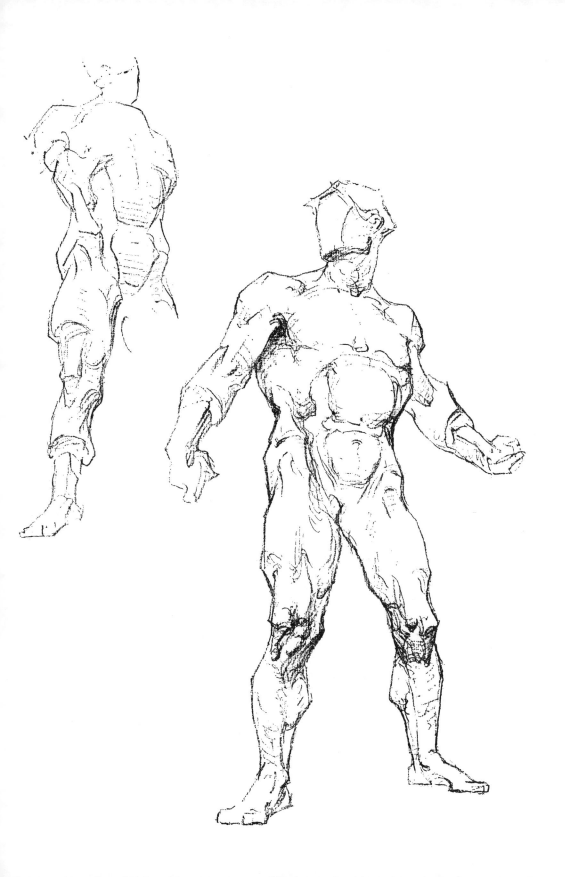

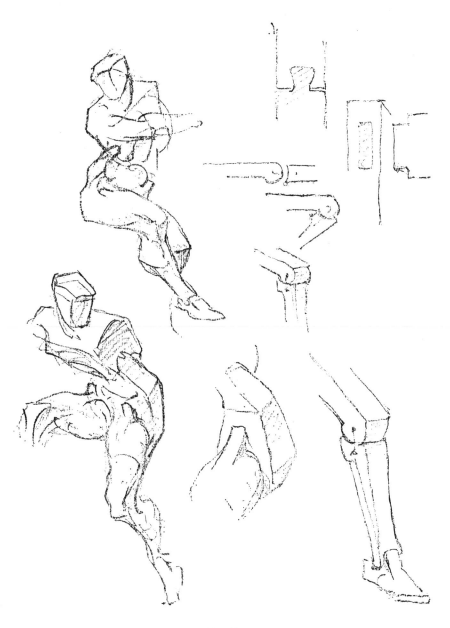

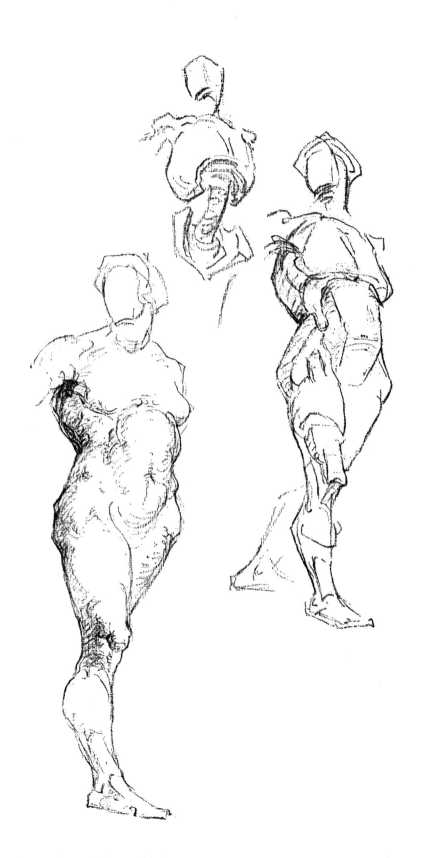

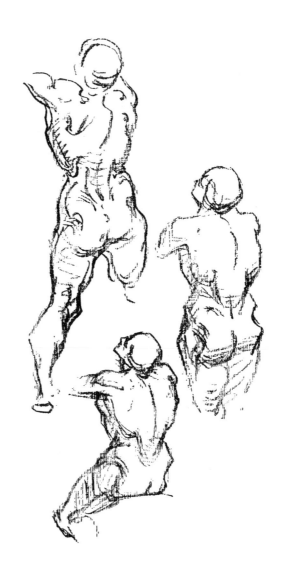

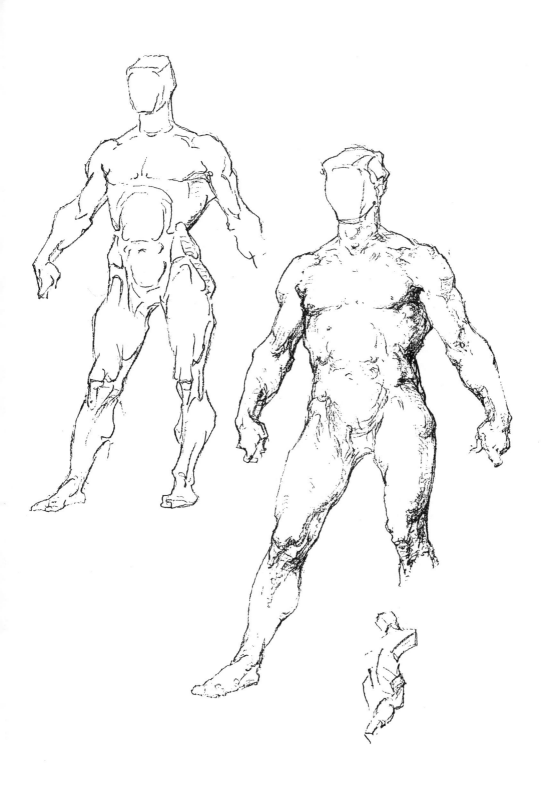

DISTRIBUTION OF
THE MASSES

It is not granted many of us to remember complex forms. So in considering the human figure it is better, at first, to think only of those major forms of which it is composed, and these may be thought of and more easily remembered by a simple formula such as the following:

Considering the Wedging and Passing of Forms from the front of the figure—The square ankle passes into the triangular calf of the leg and this in turn passes into the square knee. The square knee passes into the round thigh and the round thigh into the mass of the hips, from the sides of which a triangular wedge enters the rib cage. The rib cage is oval below, but approaches a square across the shoulders. Into this square enters the column of the neck which is capped by the head. The head when compared with the form of the neck, is square.

Considering the Wedging and Passing of Forms from the Rear of the Figure—The head is square, capping the round neck. The rib cage is square at the shoulders, wedging into the neck, and triangular below, wedging into square hips. The square hips rest on the round pillars of the thighs. The knees are square, the calves triangular and the ankles square.

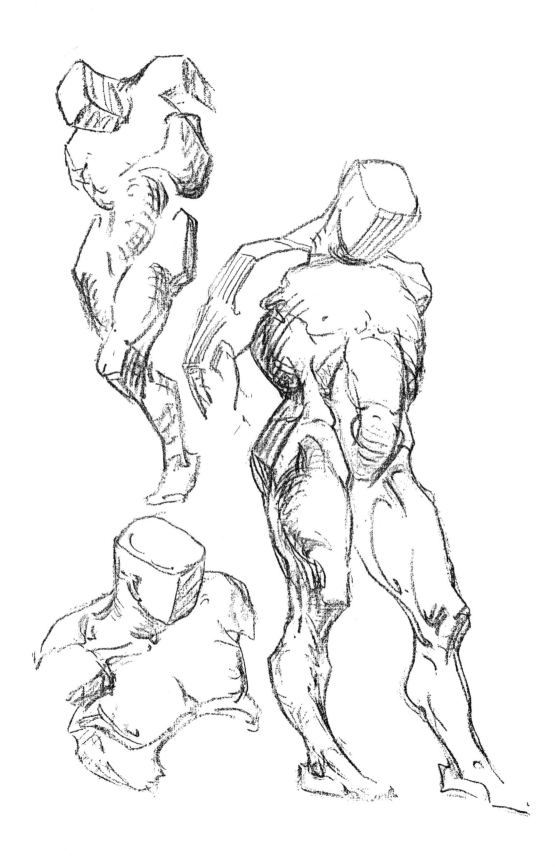

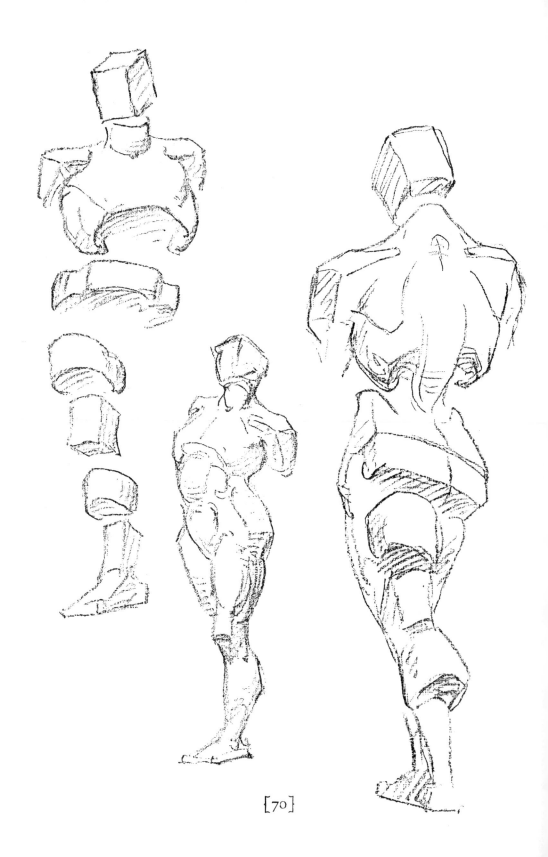

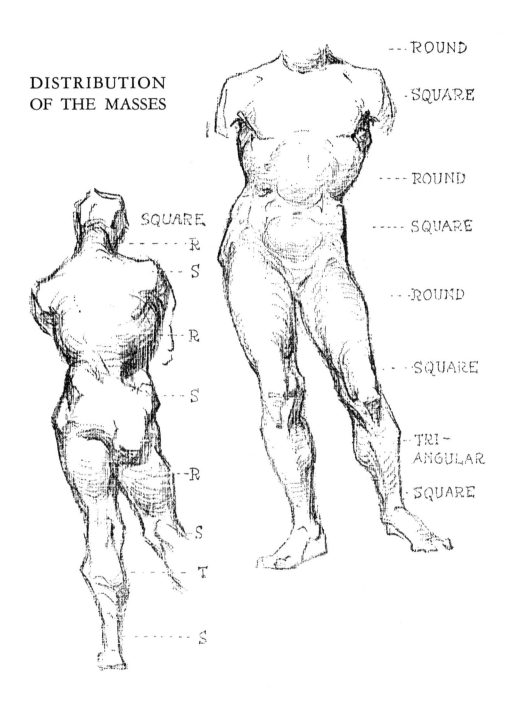

DISTRIBUTION
OF THE MASSES

---ROUND

-SQUARE

----ROUND

----SQUARE

--ROUND

- SQUARE

-- TRI-
ANGULAR

SQUARE

SQUARE
----- R
---- S

-- R

- S

-- R

-- S

----- T

----- S

LIGHT & SHADE

SHADE with the idea that light and shade are to aid the outline you have drawn in giving the impression of solidity, breadth and depth. Keep before you the conception of a solid body of four sides composed of a few great masses, and avoid all elaborate and unnecessary tones which take away from the thought that the masses or planes on the sides must appear to be on the sides while those on the front must appear to be on the front of the body. No two tones of equal size or intensity should appear directly above one another or side by side; their arrangement should be shifting and alternate. There should be a decided difference between the tones. The number of tones should be as few as possible. Avoid all elaborate or unnecessary tones and do not make four tones or values where only three are needed. It is important to keep in mind the big, simple masses and to keep your shading simple, for shading does not make a drawing.

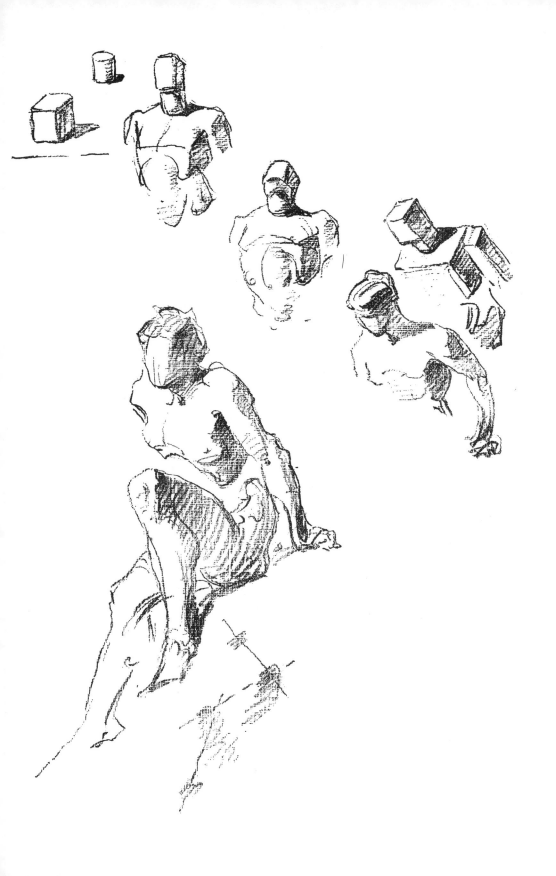

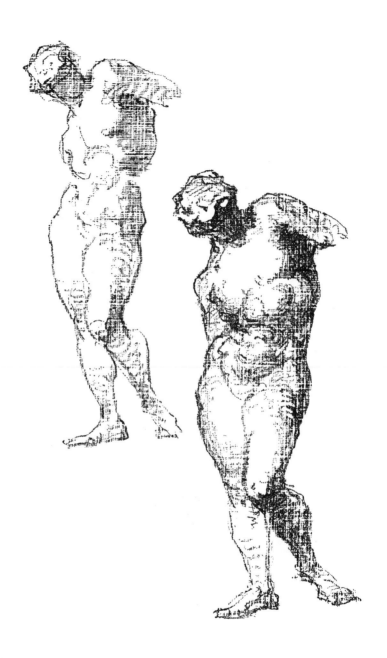

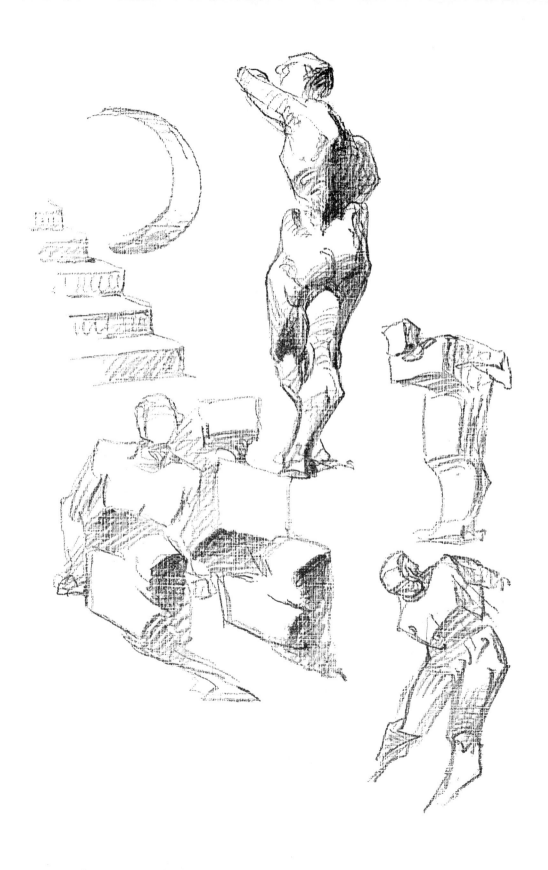

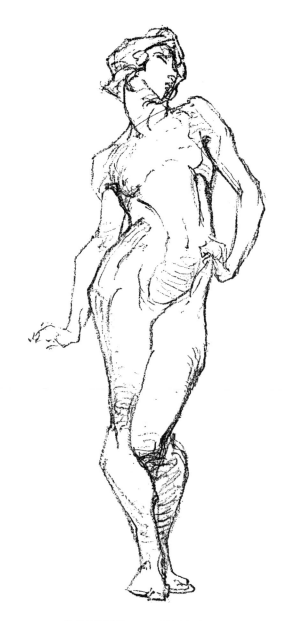

LIGHT & SHADE

[78]

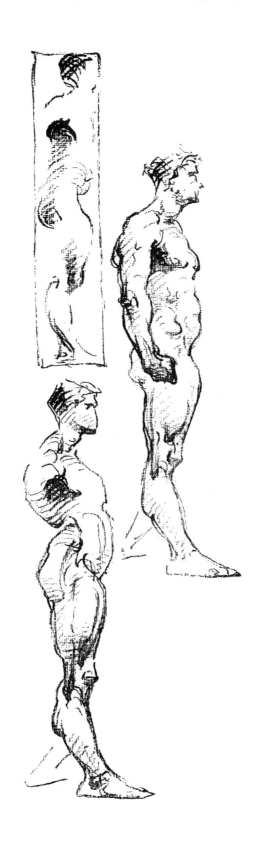

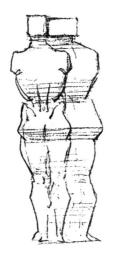

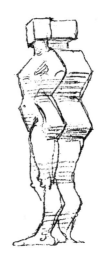

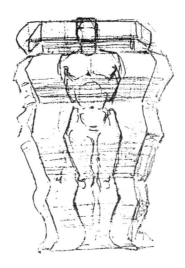

[80]

MOULDINGS

A<small>RCHITECTURAL</small> mouldings consist of alternate rounds and hollows, of plane or curved surfaces, placed one beneath the other to give various decorative effects by means of light and shade.

The human figure,whether standing erect or bent, is composed of a few big, simple masses that in outline are not unlike the astragal, ogee, and apophyge mouldings used in architecture. Looking at the back of the figure, there is the concave sweep of the mass from head to neck, then an outward sweep to the shoulders, a double curve from rib cage to pelvis, ending abruptly where the thigh begins, a slight undulation half way down to the knee, a flattened surface where it enters the back of the knee, another outward sweep over the calf and down to the heel; the whole, a series of undulating, varied forms. And the front of the figure curves in and out in much the same manner, a series of concave and convex curves, and planes.

The distribution of light and shade brings out these forms.

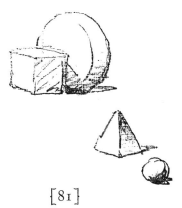

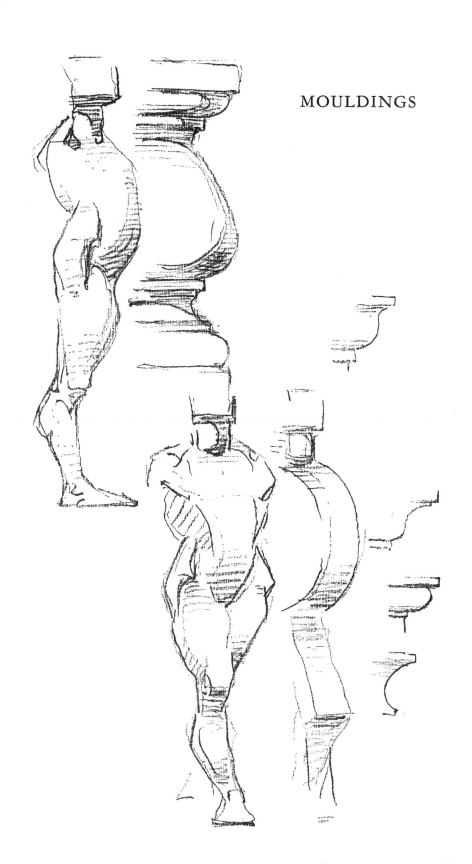

MOULDINGS

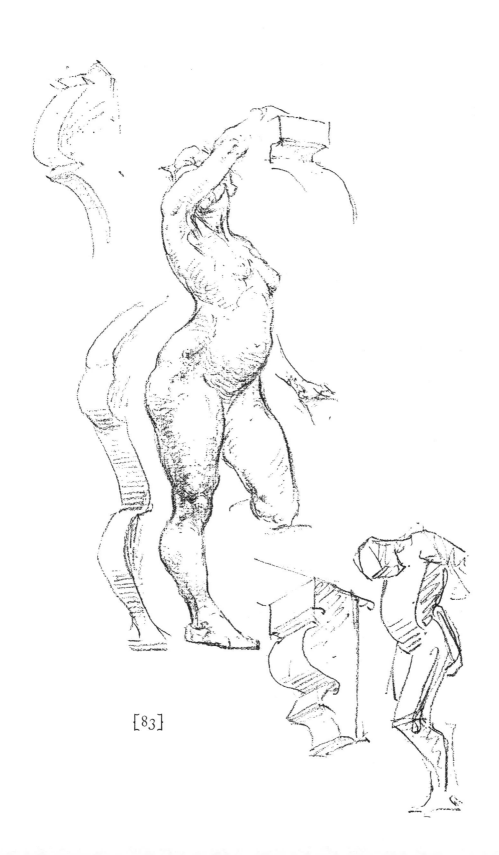

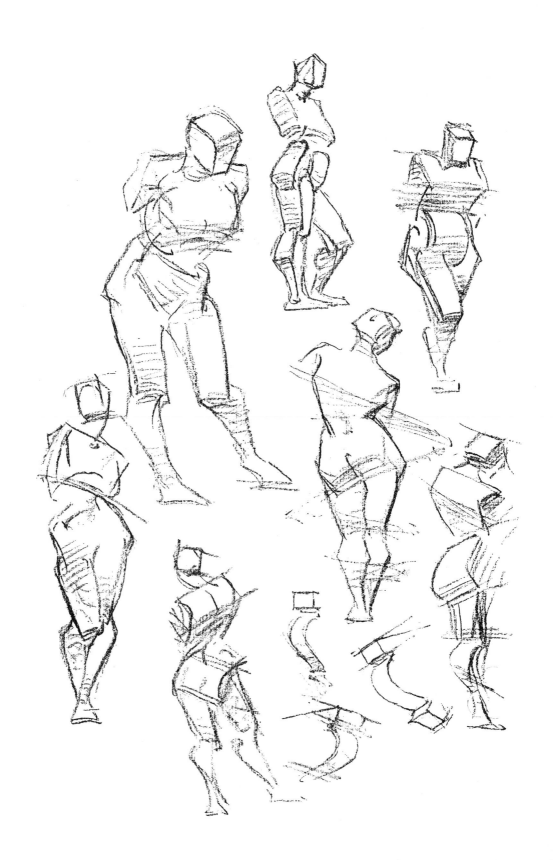

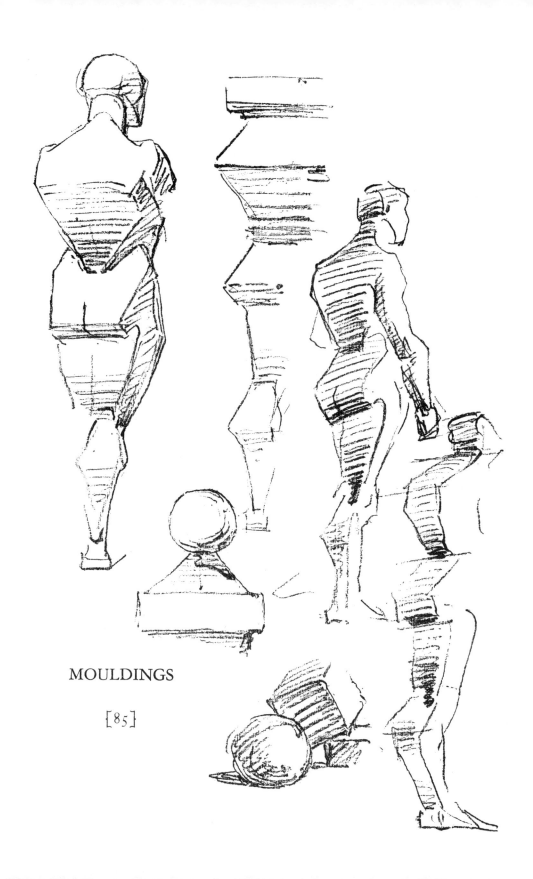

MOULDINGS

[85]

PROPORTION

ᘜ

ALL measurements of the human figure are divisions
of the body into parts of given measurements. There
are many conceptions of measuring, scientific and
ideal, and they all differ.

If given proportions were used, even though these
proportions were the ideal average, they would re-
sult in a drawing without character. Again, to apply
these so-called canons of art, the figure must be on the
eye level, upright and rigid. The least bending of the
head or body would change the given proportions
visually, though not actually.

From an anatomical point of view, taking the skull
as a unit, horizontally, the bone of the upper arm, the
humerus, is about one and one-half heads in length.
The bone on the thumb side of the fore-arm, the
radius, is about one head in length. The fore-arm
bone, the ulna, on the little finger side, measures
about one head from elbow to wrist. The thigh bone,
or femur, measures about two heads, and the leg
bone, or tibia, nearly one and one-half heads.

On the opposite page are shown three different
methods of measurement; one by Dr. Paul Richer, one
by Dr. William Rimmer and one by Michelangelo.

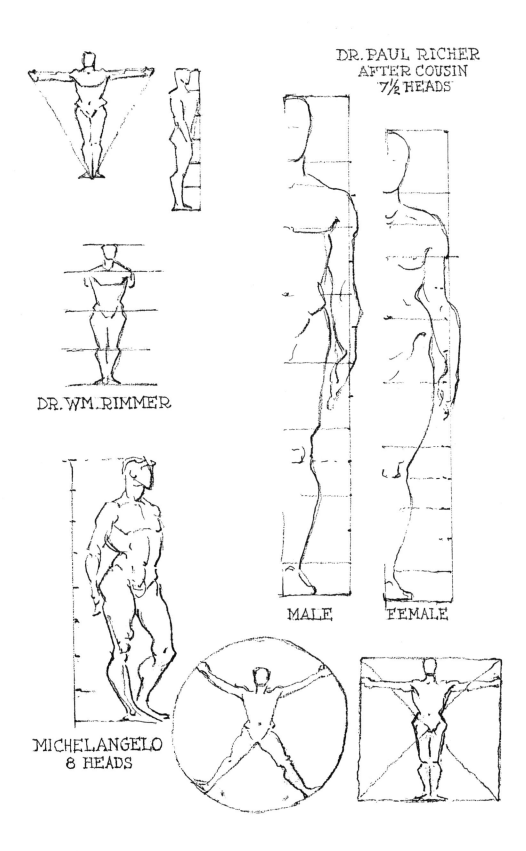

DR. PAUL RICHER
AFTER COUSIN
7½ HEADS

DR. WM. RIMMER

MICHELANGELO
8 HEADS

MALE FEMALE

HOW TO MEASURE

Y ou have to measure, first of all, with your eye and
by studying the model judge the comparative meas-
urements of its several masses. Then measure me-
chanically. When measuring mechanically, hold your
charcoal or pencil between the thumb and fingers and
use the first finger and the tip of your charcoal to
mark the extremities of the measurement you are
taking. Your arm should be extended to its full
length and your head so tilted that your eye is as
near as possible to the shoulder of the arm you are
using in measuring.

From the model, the space registered from the first
finger to the end of your charcoal or pencil might be
one inch; but on your drawing this measurement
could possibly be two or more inches. In other words,
all your measurements are comparative and if the
head spaces seven times into the length of the figure
and registers, say, one inch on your charcoal or pen-
cil, obviously the height of seven heads should be
marked off on your drawing regardless of the size of
your drawing, which size you had, in a general way,
predetermined and may be anywhere from miniature
to mural. The arm has its axis at its connection with
the shoulder blade. The eye, being above the arm and
more forward, has an entirely different axis and
radius; arms and necks vary in length. Also, in meas-
uring, as in target practice, it is natural for some to
close the left eye, others the right, and still others to
keep both eyes open. So, with these varying condi-

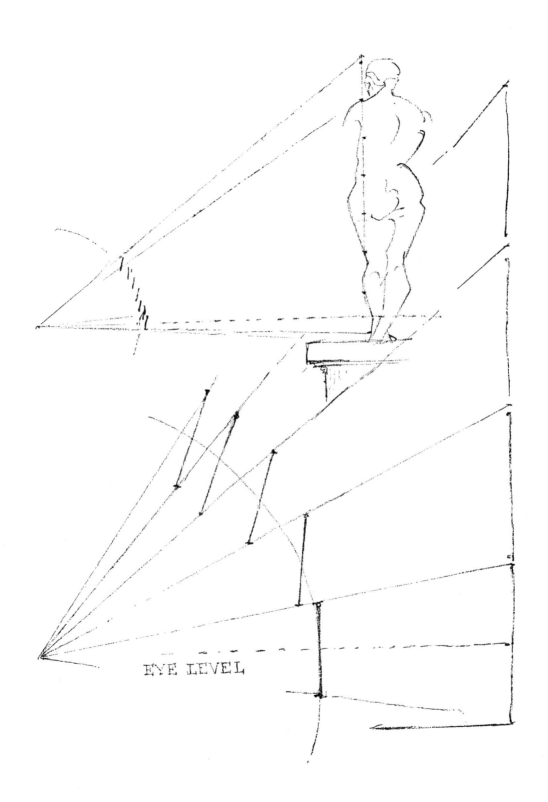

EYE LEVEL

tions it is difficult to set down any fixed rules for the technique of measuring, your own physique and tendency to use one or both eyes are such important factors. In any case, however, you *must* keep your eye as close as possible to the shoulder, your arm extended and stiff.

On a figure, there are no marks that might be used in proving your measurements correct. Again, the model may be far above the level of the eye, causing violent perspective. Only at the eye level can the pencil be held perpendicularly. Above or below the eye level, the pencil or charcoal must take some studied and given angle, and to accurately determine this angle requires some practice. To find this angle, take a panelled wall or a vertical pole and upon it mark off six or seven spaces a foot or so apart. Then seat yourself several feet away and at arm's length, with eye close to shoulder, incline charcoal or pencil to register correctly each of the spaces you have marked off. As in revolver practice, you will become extremely accurate in judging the angle at which the charcoal should be held at different distances. This same method of angles may then be applied to measuring the figure.

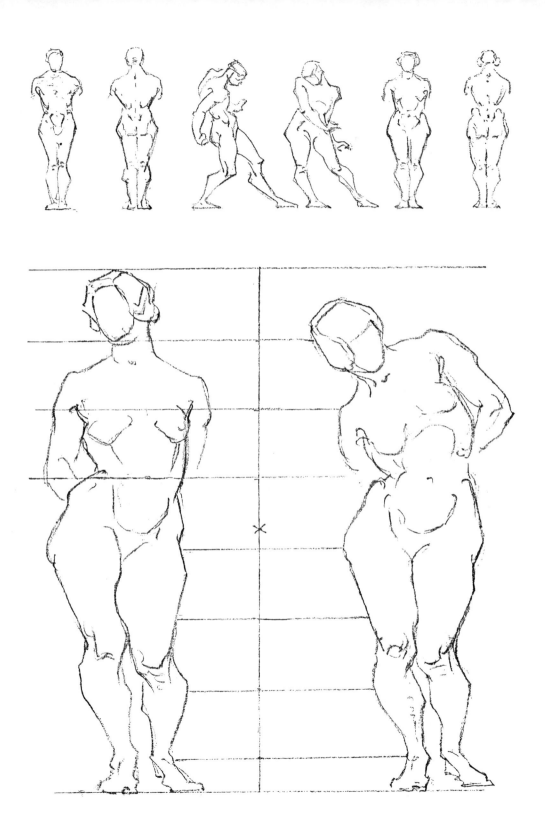

MOVABLE MASSES

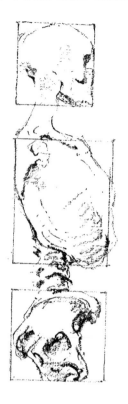

HEAD
8 inches High
7½ inches Deep
6 inches Wide

CAGE
12 inches High
8 inches Deep
10 inches Wide

PELVIS
8 inches High
6 inches Deep
10 inches Wide

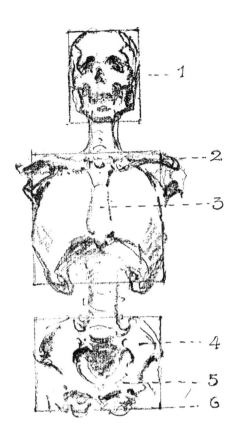

1. CRANIUM
 Skull

2. CLAVICLE
 Collar Bone

3. STERNUM
 Breast Bone

4. ILIUM

5. PUBIS

6. ISCHIUM
 Pelvis Bones

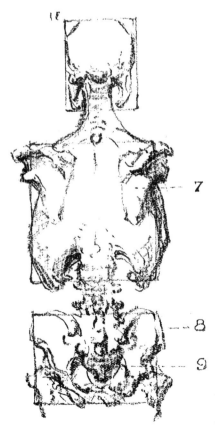

7. SCAPULA
 Shoulder Blades

8. CREST OF
 ILIUM

9. SACRUM

HEAD & FEATURES

The Head

At first the study of heads should be in the abstract, that is, we should forget everything that distinguishes one head from another and think of the masses common to all heads. Heads are about the same size. Each is architecturally conceived, constructed and balanced; each is a monumental structure.

By first mentally conceiving of a head as a cube, rather than as an oval or egg-shaped form, we are able to make simple, definite calculations.

The cube of the head measures about six inches wide, eight inches high and seven and a half inches from front to back. These measurements are obtained by squaring a skull on its six sides: face, back, two sides or cheeks, top and base or lower border, which is partly hidden by the neck but is exposed under the chin and jaw, and again at the back where it is seen as the lower border of the skull. Therefore the base of this cube is about seven and a half inches deep and six inches wide, and on this "ground plan" as on that of a square, any form may be constructed.

This cube may be tilted to any angle, also foreshortened, and it may be placed in perspective.

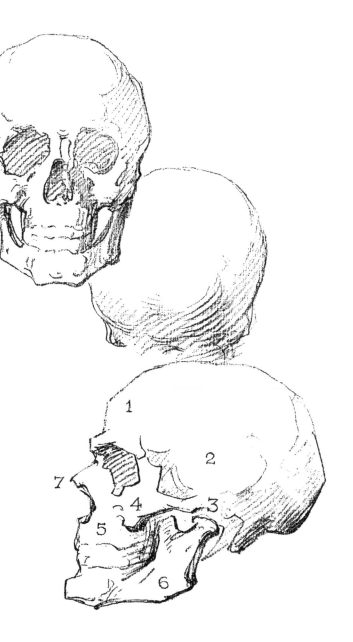

1. FRONTAL

2. TEMPORAL

3. ZYGOMATIC
 ARCH

4. MALAR

5. SUPERIOR
 MAXILLARY

6. INFERIOR
 MAXILLARY

7. NASAL

∾❊∾

The Skull

THE skeleton of the head, like the cube, has six sur-
faces: top, base, two sides or cheeks, front and back.
Its bony framework is immovable excepting the
lower jaw, which articulates. There are twenty-two
bones in the head. Eight of these bones compose the
brain case and fourteen bones compose the face. The
brain case is bounded in front by the frontal bone or
forehead, which extends from the root of the nose to
the crown of the head and laterally to the sides of the
temples. The two malar bones, or cheek bones, are
facial bones, each united to four other bones forming
a part of the zygomatic arch which spans the space
from cheek to ear. Above, the malar or cheek bone
joins the forehead at its outer angle; below it joins
the superior maxillary or upper jawbones. The two
superior maxillary bones constitute the upper jaw
and cylinder that hold the upper row of teeth. They
are attached above to the cheek bones and eye cavi-
ties. The nasal bones form the bridge of the nose.

The inferior maxillary or lower jawbone is the
lower border of the face. It is shaped like a horse-
shoe, its extremities ascending to fit into the tem-
poral portion of the ear. It is a mandible, working on
the principle of a hinge moving down or up as the
mouth opens or closes, but with a certain amount of
play, sideways and forward, so that when worked by

the masseter muscles the food is not simply hammered or flattened, but ground by the molar or grinding teeth. The masseter muscle extends from under the span of the zygomatic arch to the lower edge and ascending angle of the lower jaw. It is the large muscle raising the lower jaw, used in mastication. It fills out the side of the face, marking the plane which extends from the cheek bone to the angle of the jaw.

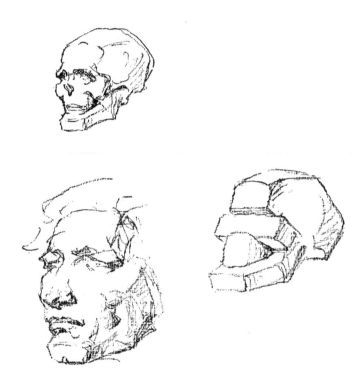

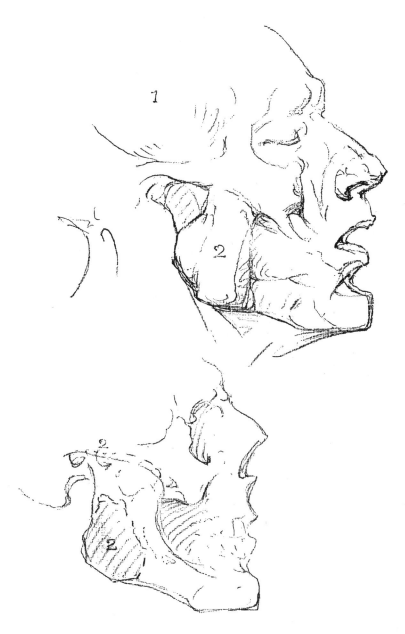

1. TEMPORAL
2. MASSETER

THE SKULL

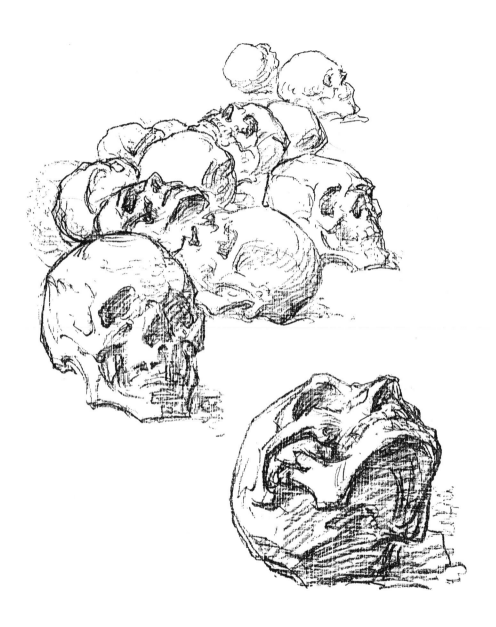

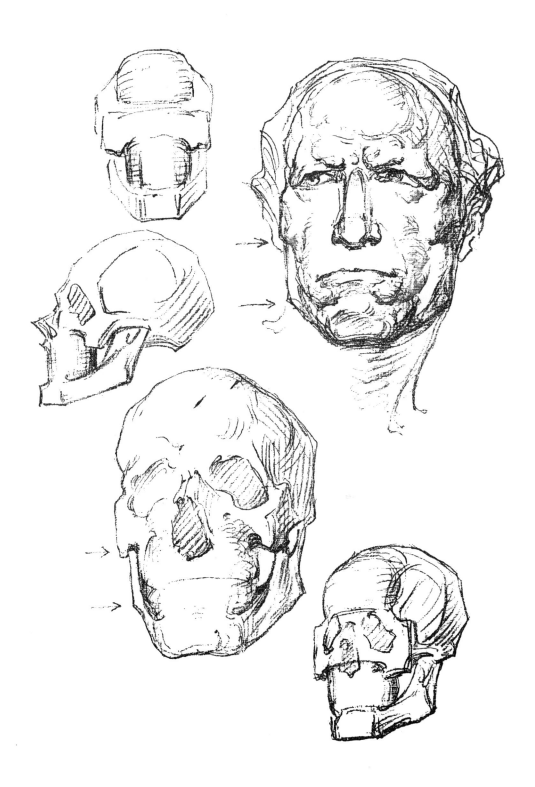

HEAD & FEATURES

Drawing the Head

BEGIN by drawing with straight lines the general outline of the head.

Then draw the general direction of the neck from its center, just above the Adam's apple, to the pit, at the junction of the collar bones. Now outline the neck, comparing its width and length with the head.

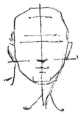

Draw a straight line through the length of the face, passing it through the root of the nose, which is between the eyes, and through the base of the nose where the nose centers in the upper lip.

Draw another line from the base of the ear at a right angle to the one you have just drawn.

On the line passing through the center of the face, measure off the position of the eyes, mouth and chin. A line drawn through these will parallel a line drawn from ear to ear, intersecting, at right angles, the line drawn through the vertical center of the face.

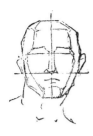

With straight lines, draw the boundaries of the forehead, its top and sides, and the upper border of the eye sockets. Then draw a line from each cheek bone at its widest part, to the chin, on the corresponding side, at its highest and widest part.

If the head you are drawing be on a level with your eyes, the lines you have just drawn will intersect at right angles at the base of the nose and if both ears are visible and the line from the ear extended across the head, it will touch the base of both ears.

Considering the head as a cube, the ears opposite each other on its sides or cheeks and the line from ear to ear as a spit or skewer running through rather than around the head.

If the head be above the eye level, or tilted backward, the base of the nose will be above this line from ear to ear. Or should the head be below the eye level or tilted forward, the base of the nose will be below the line from ear to ear. In either case, the head will be foreshortened upward or downward as the case may be and the greater the distance the head is above or below the eye level the greater the distance between the line from ear to ear and the base of the nose.

You now have the boundaries of the face and the front plane of the cube. The features may now be drawn in.

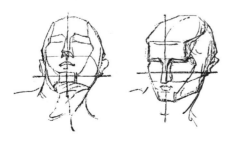

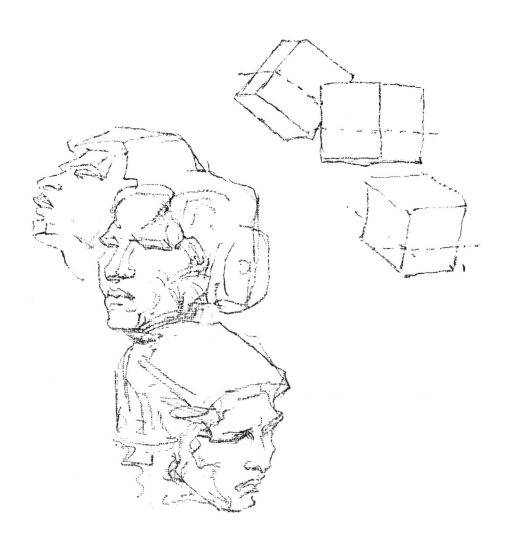

Perspective

It is possible only to touch upon the subject of perspective.

Perspective refers to the effect of distance upon the appearance of objects and planes. There are to be considered parallel perspective, angular perspective and oblique perspective.

Parallel lines which do not retreat do not appear to converge. Retreating lines, whether they are above or below the eye, take a direction toward the level of the eye and meet at a point. This point is called the center of vision, and it is also the vanishing point in parallel perspective. In parallel perspective, all proportions, measurements and locations are made on the plane that faces you. So in drawing a square, a cube or a head, draw the nearest side first.

When an object is turned to right or left, so that the lines do not run to the center of vision, then the center of vision is not their vanishing point and the object is said to be in angular perspective.

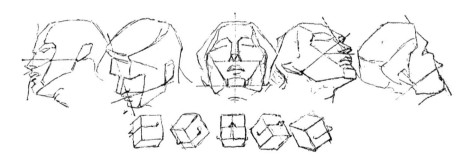

PERSPECTIVE

When an object, such as a cube, is tilted or turned from the horizontal it is said to be in the oblique perspective. These few remarks upon a vast subject are made to accompany the drawings which it is hoped will explain themselves. Everyone is conscious of perspective and may find its elucidation in geometry and many books upon the subject.

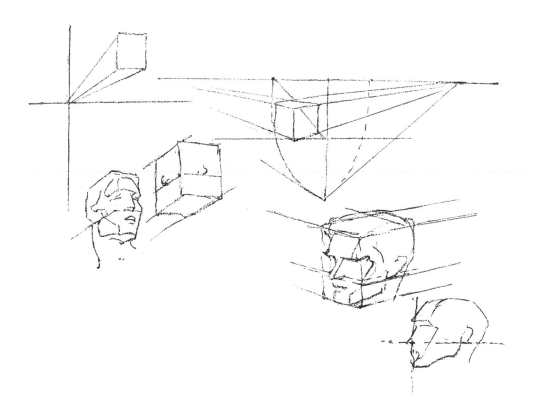

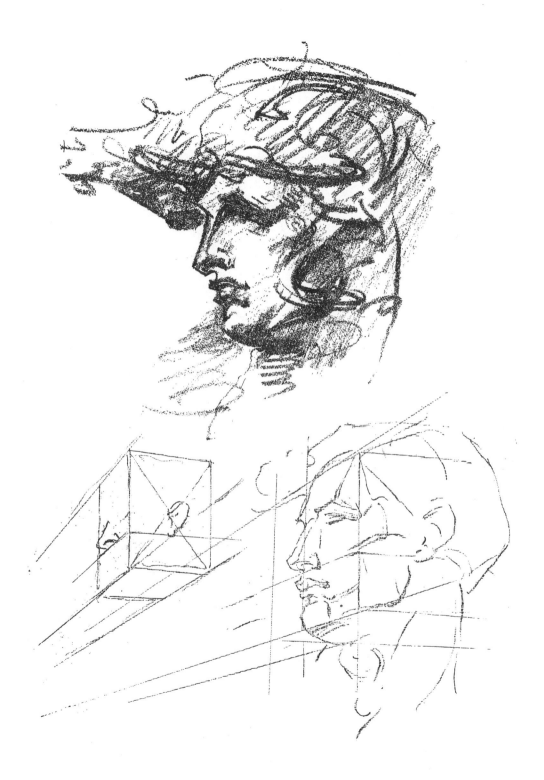

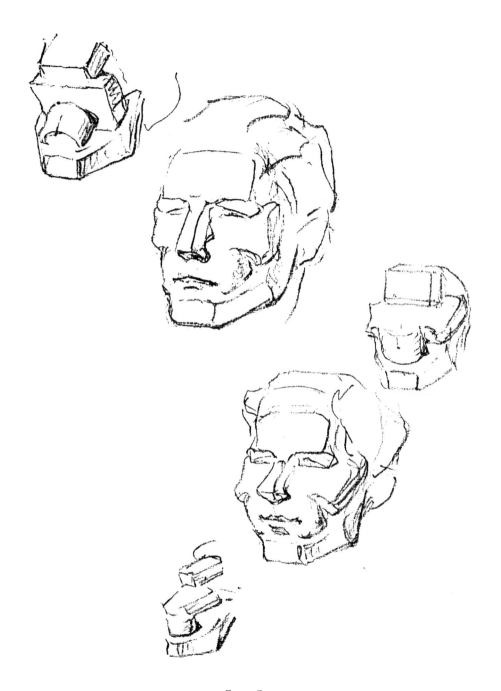

Distribution of the Masses

Four distinct forms compose the masses of the face.

1. They are, the forehead, square and passing into the cranium at the top.

2. The cheek-bone region which is flat.

3. An erect, cylindrical form on which are placed the base of the nose and the mouth.

4. The triangular form of the lower jaw.

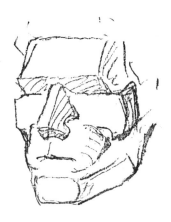

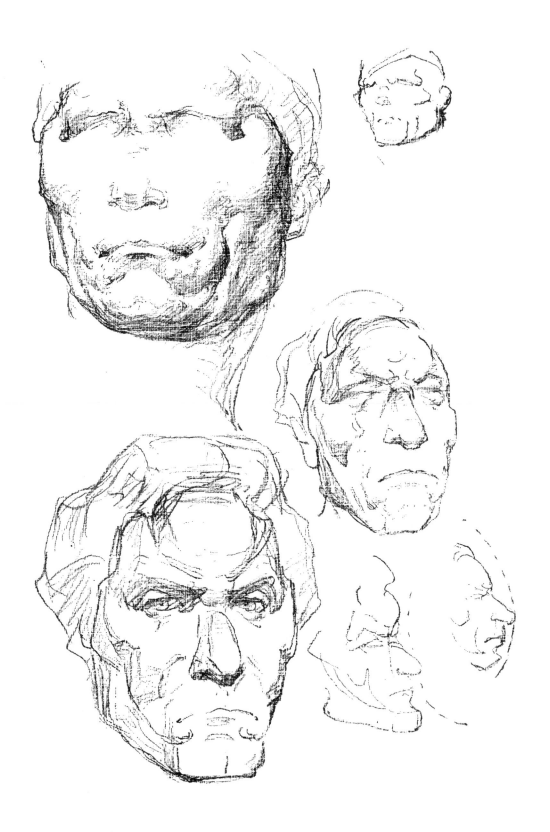

HEAD & FEATURES

Building

I<small>T</small> is the placing and locking of these forms that gives solidity and structural symmetry to the face, and it is their relative proportion as well as the degree to which each tilts forward or backward, protrudes or recedes, that makes the more obvious differences in faces.

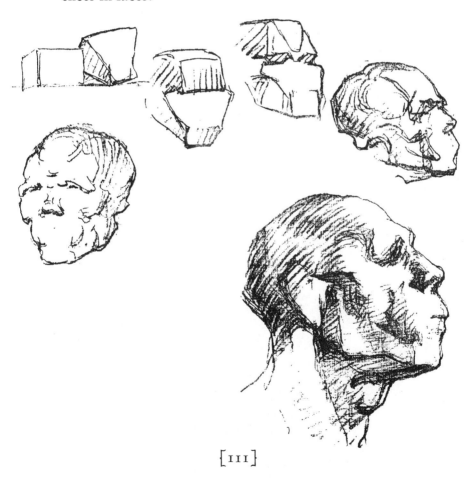

HEAD & FEATURES

Planes

I n considering the distribution of the masses of the head, the thought of the masses must come first; that of planes, second. Planes are the front, top and sides of the masses.

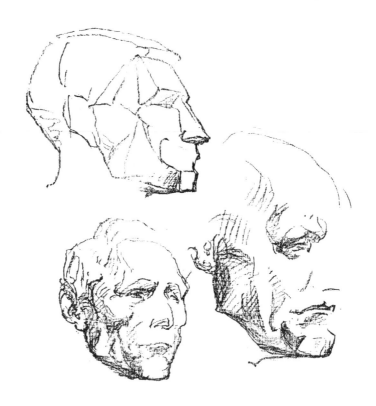

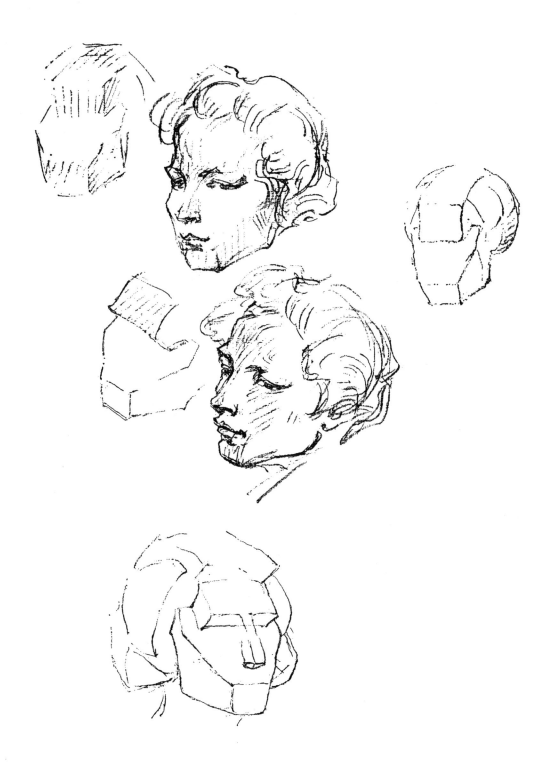

Mouldings

F<small>ROM</small> forehead to chin a face that is not flat either protrudes or recedes, curving outward or inward, alternating as to curves and squares of varied forms. In this respect a face in profile resembles architectural mouldings.

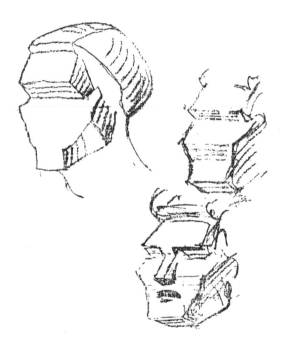

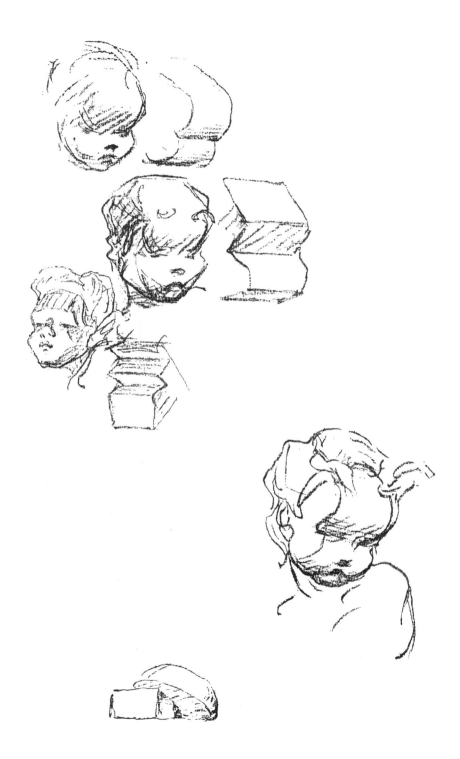

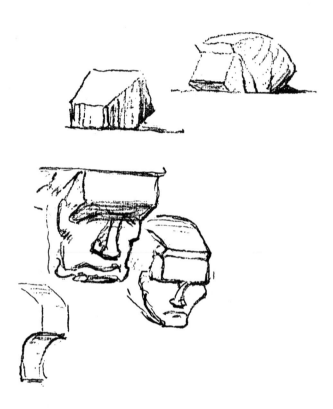

HEAD & FEATURES

[118]

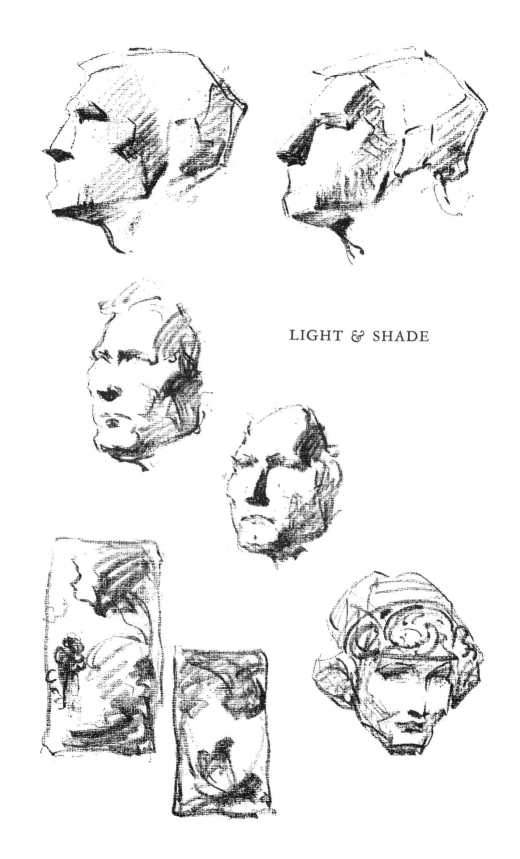

LIGHT & SHADE

HEAD & FEATURES

※

The Eye

Above the eye socket, or orbit, the frontal bone is buttressed and of double thickness, the cheek bones beneath are reinforced and the entire bony structure surrounding the eye is designed to protect this most vulnerable and expressive feature of the face.

The eye, cushioned in fat, rests in this socket. In shape, the eyeball is somewhat round. Its exposed portion consists of pupil, iris, cornea and the "white of the eye." Due to the transparent covering, or cornea, which fits over the iris, much as a watch crystal fits over a watch, making a part of a smaller sphere laid over a larger one, the eye is slightly projected in front.

It is the upper lid that moves. Its curtain, when closed, is drawn smoothly over the eye; when open, its lower part follows the curve of the eyeball, like the roll top of a desk, folding in beneath the upper part and leaving a wrinkle to mark the fold. The transparent cornea of the eye, raised perceptibly and always partly covered by the upper lid, makes this lid bulge. This bulge on the lid travels with the eyeball as it moves, whether opened or closed.

The lower lid is quite stable. It may be wrinkled and slightly lifted inward, bulging below the inner end of the lid. The lashes which fringe the upper and lower lids from their outer margin, shade the eye and serve as delicate feelers to protect it, the upper lid instinctively closing when they are touched.

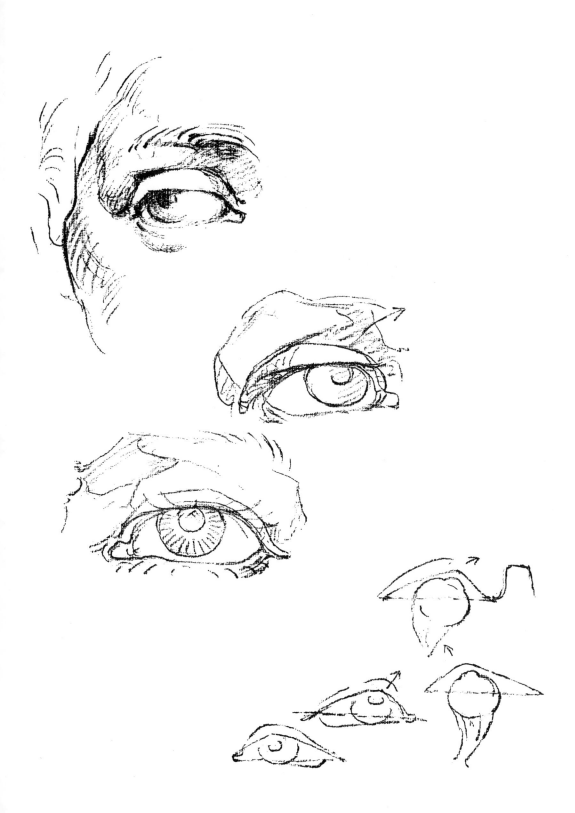

❦

The Nose

THE nose is in the center of the front plane of the face. Its shape is wedge-like, its root in the forehead and its base at the center of the upper lip. As it descends from the forehead it becomes larger in width and bulk, and at its base it is held up in the middle and braced from the sides by cartilages.

The bony part of the nose descends only half way from its root and is composed of two nasal bones. The lower part is composed of cartilages, five in all: two upper, two lower laterals and one dividing the nasal cavities.

Two wedges meet on the nose, a little above the center at a point called the bridge of the nose. The direction of one is toward the base of the forehead between the eyes; that of the other toward the end of the nose, diminishing in width as it enters the bulbous portion at the tip. An upright wedge is seen as a narrow cartilage at the upper margin of the curtain of the upper lip, where it divides the nasal cavity into two parts. The outer walls of the cavities are called wings; they are more angular than round and are known as the buttresses of the nose.

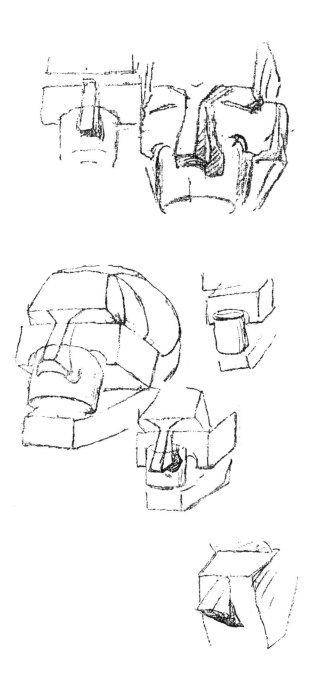

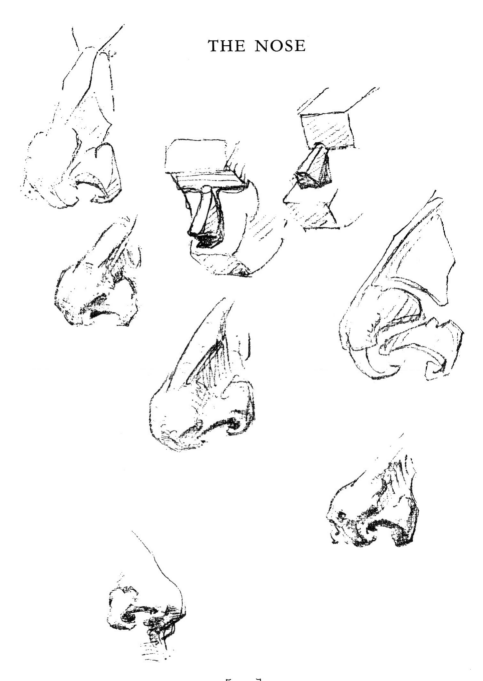

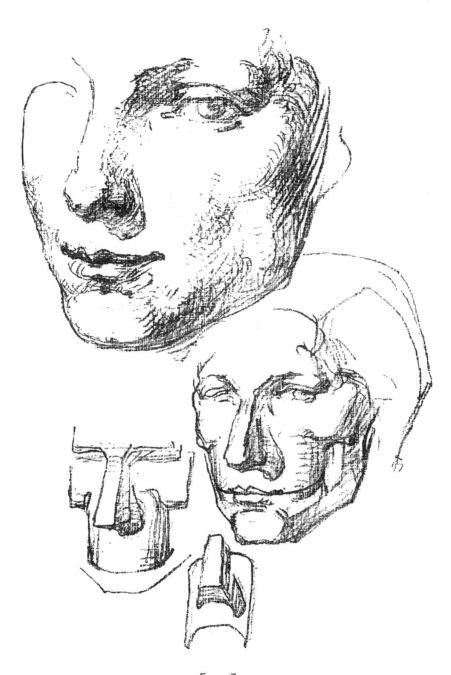

᳁ꝛ᳁

The Mouth

T HAT part of the jaws in which the teeth are set is cylindrical in shape and controls the shape of the mouth. If the cylinder be flat in front, the lips will be thin and the mouth a slit. The greater the curve of this cylinder, the fuller and more bow-shaped will be the mouth and lips.

From the base of the nose to the upper red lip, this curtainous portion of the mouth has a central vertical groove and pillars on either side which blend into broad, drooping wings ending, at the corners of the mouth, in fleshy eminences called the pillars of the mouth.

The upper red lip has a central wedge-shaped body, indented at the top by the wedge of the groove above, and two long, slender wings disappearing under the pillars of the mouth. The lower red lip has a central groove with a lateral lobe on either side. It has three surfaces; the largest depressed in the middle at the groove, a smaller one on either side diminishing in thickness, curving outward, and not so long as those of the upper red lip.

Below the lower red lip, the curtainous portion of the mouth slopes inward and ends at the cleft in the chin. It has a small, linear central ridge and two large, lateral lobes, bounded by the pillars of the mouth.

[126]

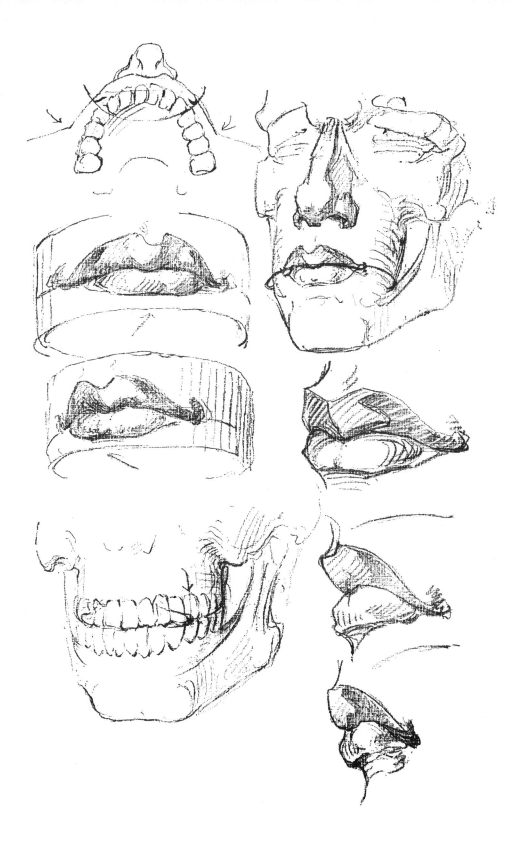

The Ear

THE ear, irregular in form, is placed on the side of the head. The line of the ear toward the face is on a line with the upper angle of the lower jaw. The ear, in man, has lost practically all movement. It is shaped like half of a bowl with a rim turned out, and below is appended a piece of fatty tissue called a lobe. Its muscles which in primitive times, no doubt, could move it to catch faint sounds, now serve only to draw it into wrinkles, which, though varying widely, have certain definite forms. There is an outer rim often bearing the remains of a tip, an inner elevation in front of which is the hollow of the ear with the canal's opening protected in front by a flap and behind and below by smaller flaps.

The ear has three planes divided by lines radiating from the canal, up and back and down and back. The first line marks a depressed angle between its planes. The second marks a raised angle.

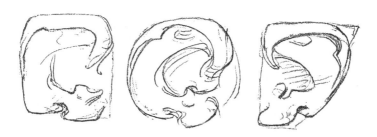

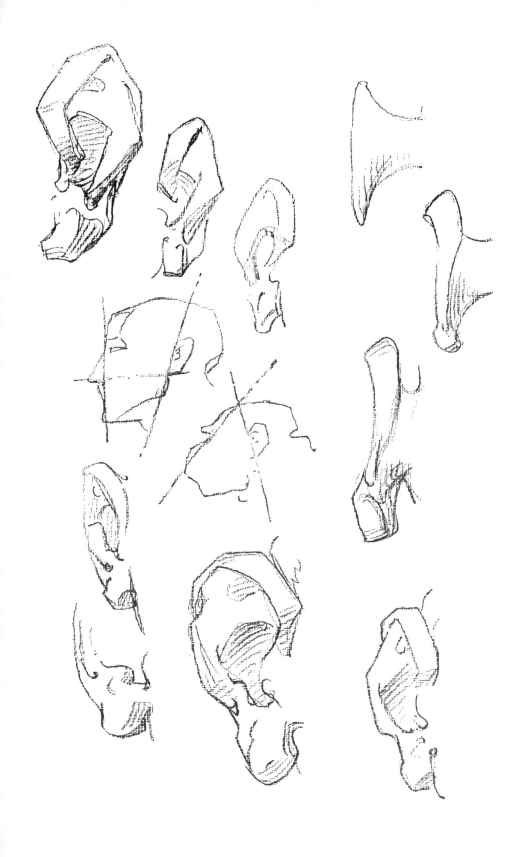

❀

The Neck

THE neck is cylindrical in shape, following the curve of the spinal column; even when the head is thrown back the neck curves slightly forward.

In front, it is rooted at the chest and canopied above by the chin. In back it is somewhat flattened and the back of the head overhangs it. The neck is buttressed on each side by the shoulders. From behind each ear a muscle descends inward to the root of the neck. These muscles almost meet each other, making a point at the pit. They form, in fact, on the front plane of the neck, the sides of an inverted triangle whose base is the canopy of the chin. The two muscles referred to are called bonnet strings. Into this triangle are set three prominent forms: a box-shaped cartilage called the larynx or voice-box, just below it a ring of cartilage called the cricoid cartilage, and beneath these a gland called the thyroid gland. In men, the voice-box or larynx is larger; in women, the thyroid gland is more prominent. The whole is known as the Adam's apple. The neck has the following action: up and down, from side to side, and rotary.

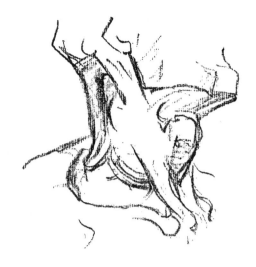

THE
NECK

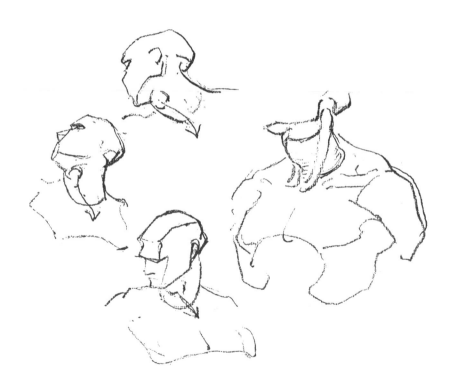

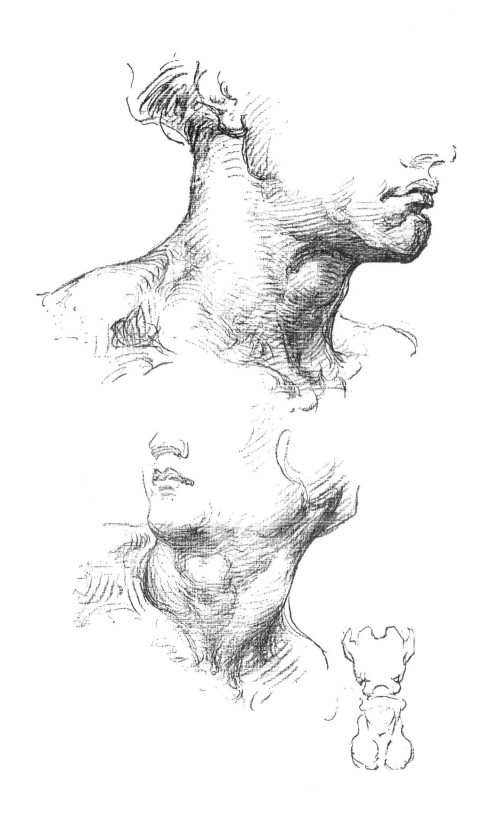

TORSO—FRONT

The thorax, or chest, is composed of bones and cartilages. It is designed not only to protect the heart and lungs, which it contains, but also to allow the whole mass to be turned and twisted with the different movements of the body. This cage is formed, at the back, by the spinal column, on the sides by the ribs, and in front by the breastbone. It protects the heart and lungs as a baseball mask protects the face; its structure is yielding and elastic, so that it may serve as a bellows. The ribs are not complete circles, nor do they parallel each other; they incline downward from the spine and bend at an angle at the sides, to take a forward thrust toward the breastbone. The breastbone is called the sternum.

If each rib were rigid and circular, the chest would be immovable and no chest expansion could take place. According to Keill, the breastbone, with an easy inspiration, is thrust out one-tenth of an inch, allowing forty-two cubic inches of air to enter the lungs; and this may be increased, with effort, to seventy or even one hundred cubic inches.

The pelvis is the mechanical axis of the body. It is the fulcrum for trunk and legs, and is large in proportion. Its mass inclines a little forward and as compared with the trunk above is somewhat square. The ridge at the sides is called the iliac crest and this is the fulcrum for the lateral muscles; it flares out widely for this purpose, rather more widely in front than behind.

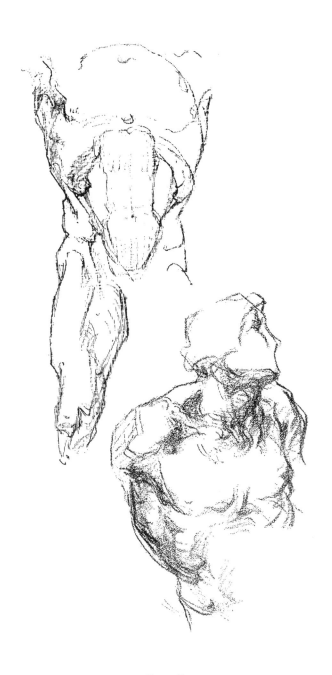

ABDOMINAL ARCH

Iғ you have made a little manikin of lath and wire, like the one we have described in an earlier chapter, you will note there is no bony structure between the blocks representing the chest and the pelvis, other than the lumbar or flexible portion of the spine which is represented by a strand of wire.

In front, the top of this middle portion of the torso is bounded by the line of the false ribs which arch outward and downward from the end of the breast-bone, forming the abdominal arch. This arch, the curve of which varies, separates the thorax from the abdomen. Below this arch is the most movable part of the mobile portion of the abdomen. It is bounded below by a line passing approximately through the anterior points of the iliac crests. Its profile shows the lines of the thorax cone *diverging* downward.

When the body bends and twists, the central line of this portion bends always to the convex side, paralleled by the borders of the rectus muscle.

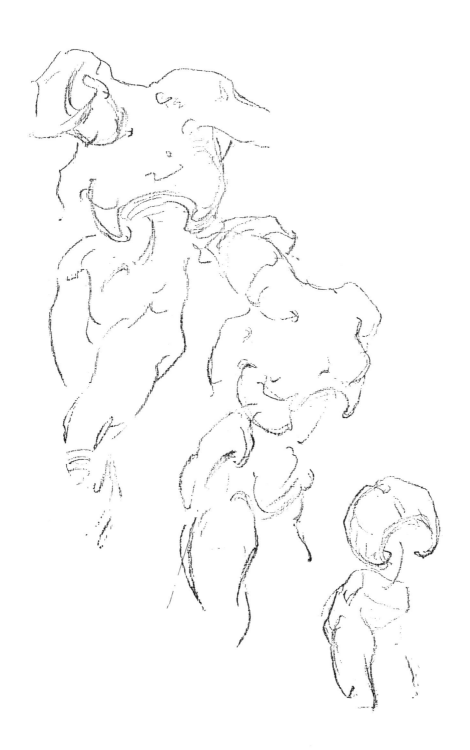

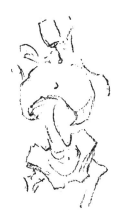

ABDOMINAL
ARCH

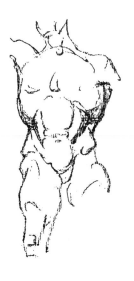

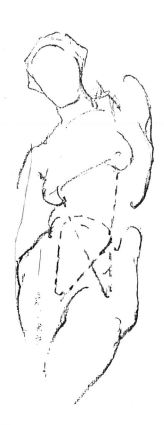

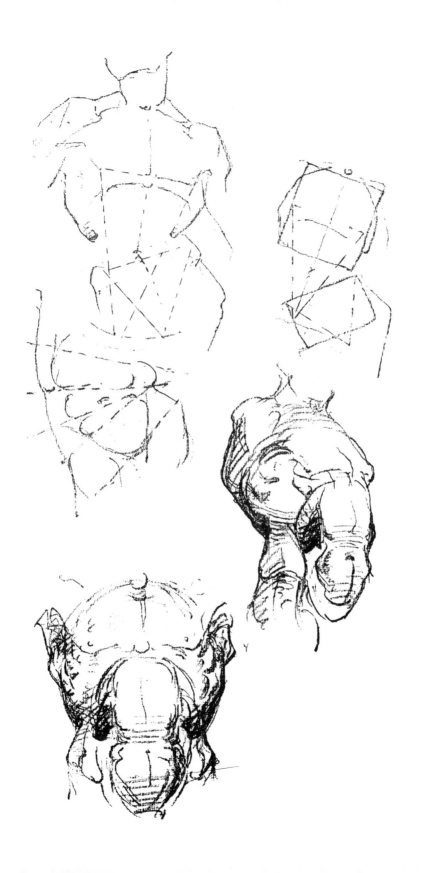

THE SHOULDER GIRDLE

The thorax or cage is encircled at the top by a girdle
of bone composed of the two scapulae or shoulder
blades, and the two clavicles, or collar bones. The
only articulation the shoulder blades have with the
cage is through the collar bones. The collar bones are
attached to the breastbone in front and have a wide
range of movement, up and down, forward and back-
ward, as well as a slight rotary movement.

As this bony girdle moves, the shoulders move,
quite independent of the cage and spine, tilting and
twisting on and around the upper portion of the cone-
shaped thorax or cage.

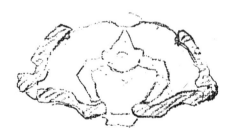

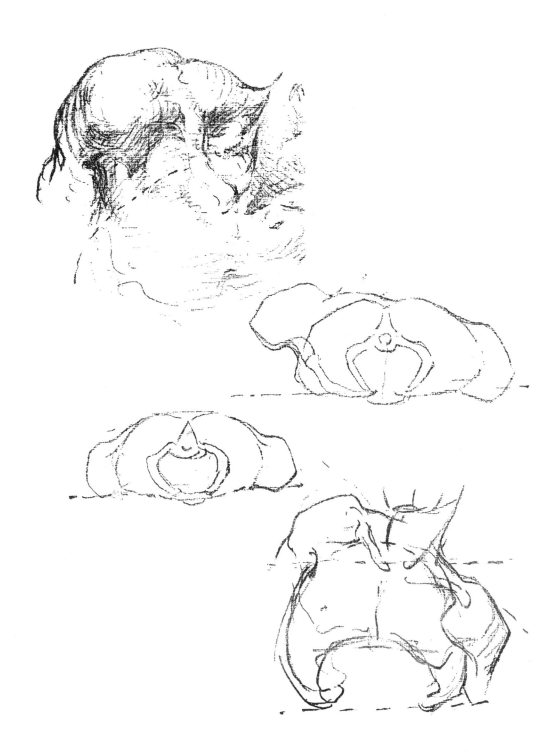

TORSO—BACK

Movement of flexion and extension occurs almost entirely in the waist or lumbar vertebrae, while movement of side-bending occurs throughout the whole length. Movement of rotation occurs in the lumbar vertebrae when the spine is erect, in the middle vertebrae when it is half flexed and in the upper vertebrae when the spine is fully bent. In the lumbar vertebrae the axis of this rotation is behind the spine, in the middle vertebrae it is neutral, and in the upper dorsals it is in front of the spine. Each vertebra moves a little and the whole movement is the aggregate of the many little movements.

The shoulder blade or scapula (spade) slides against the surface of the cage of the thorax in any direction, and may be lifted from it so that its point becomes prominent under the skin. Easily fifty per cent. of the entire movement of the shoulder is produced by the scapula.

The mass of the torso presents from the rear a great wedge, its apex downward, marked by many lesser wedges and diamonds, and by the shoulder blades. The profile of the sides presents a wide, incomplete wedge whose lines, if prolonged, would form an apex below the buttocks. The surface of the back presents a great wedge whose base is at the corners of the shoulders, the apex driven between the buttocks, buttressed on the sides by the lateral masses of waist muscle. Adding the neck, this form becomes a diamond with a very blunt top.

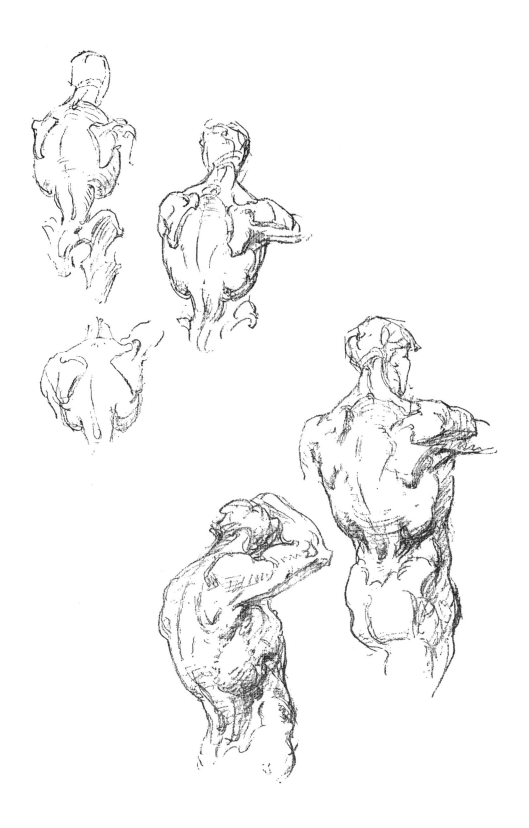

TORSO—BACK

With the torso in profile, the mass of the pelvis and abdomen slopes upward and forward. It is marked by the iliac crest and hip. It may be flattened in front by the contraction of the abdominal muscles. The hip moves freely over its surface, changing the tilt of the pelvis. Between these the central mass contains the lumbar or waist vertebrae. Practically all of the movement of flexion and extension for the entire spine occurs here, and much of the side-bending. This mass is marked by a buttress of lateral muscles, slightly overhanging the pelvic brim. It changes greatly in different positions of the trunk.

From the back the torso presents many depressions and prominences. This is due to its bony structure and to a number of thin layers of muscles which cross and recross the back.

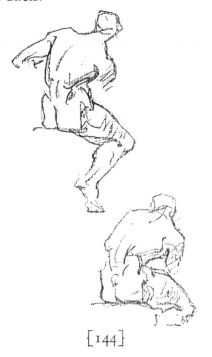

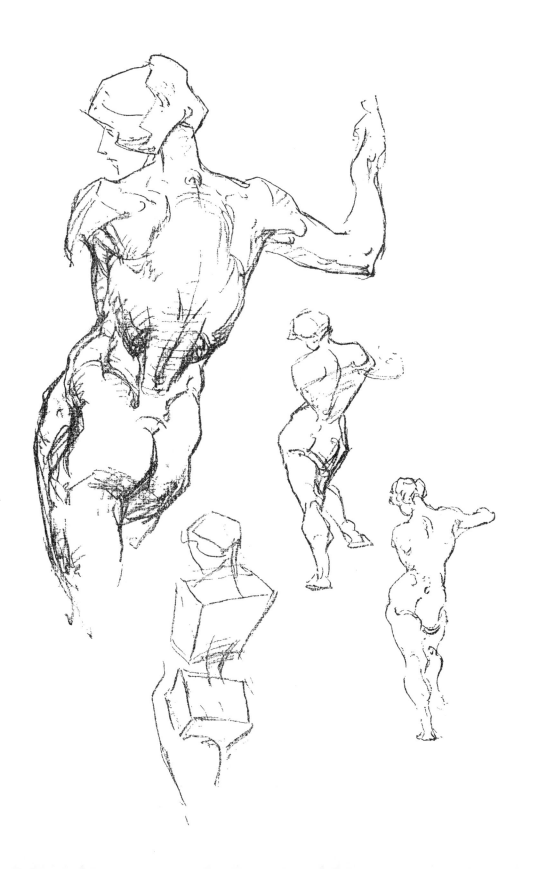

TORSO—BACK

The superficial or outside layers of these muscles manifest themselves only when in action. So, under all changes of position, it should be remembered that the spine, the shoulder blade with its acromion process, and the crest of the ilium are the landmarks of this region. The acromion process is the outer corner of the shoulder girdle, the high outer extremity of a ridge rising from the shoulder blade.

The back of the torso is divided vertically from end to end by the spine which, when bent, presents a series of knobs, the tips of vertebral spines, and when erect a groove excepting at the root of the neck. Here the spine of the seventh cervical vertebra forms a sort of ridgepole for muscular tendons for the neck and shoulders. Around it there is a flat, unbroken fascia without muscular fibres, forming a lesser diamond nestling below the upper apex.

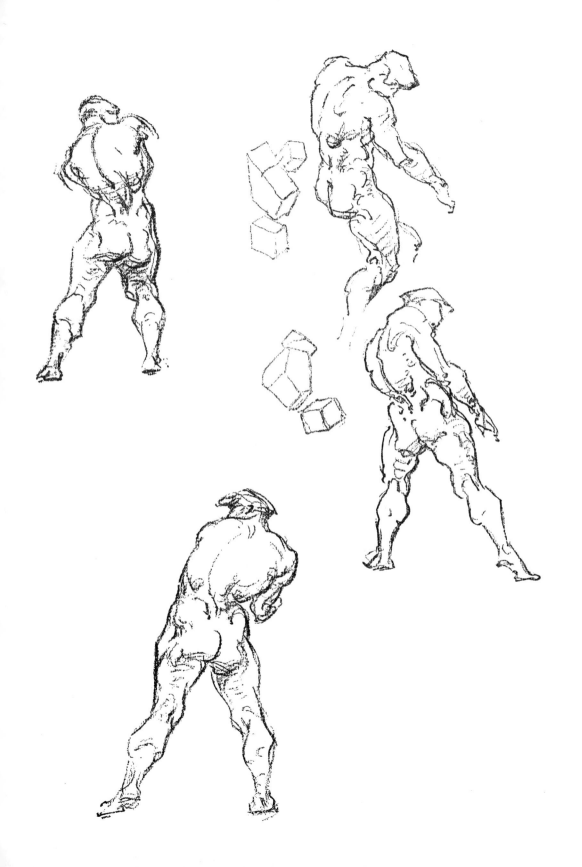

THE UPPER LIMBS

The Arm

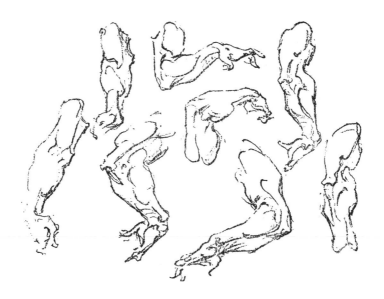

The arm has its base in the shoulder girdle. Its one bone, called the humerus, is cylindrical, slightly curved, with a spherical head fitting into the cup-shaped cavity of the shoulder blade. Its ball-and-socket joint is covered with a lubricating capsule and held together by strong braces of membranes and ligaments. These, crossing at different angles, brace the arm as well as allow great freedom of movement. The lower part of the arm ends at the elbow in a hinge joint, on the inner and outer sides of which are two prominences, called inner and outer condyles.

Both prominences show on the surface. The inner condyle is used as a point of measurement and is more conspicuous than the outer one.

The forearm has two bones. One, called the ulna, is notched to fit around the rounded surface between the two condyles of the arm, at the elbow. The extremity of the lower end of this shaft has the shape of a knob which shows plainly above the wrist on the little finger side. The other bone, called the radius, joins the wrist on the thumb side of the hand. Here it is wide, curving upward to its head, which is small and cup-shaped, a ring of ligament holding it in place below the outer condyle of the arm bone, or humerus.

The radius, on the thumb side of the wrist, radiates around the ulna on the little finger side. At the elbow, the arm and forearm act as a hinge joint.

The mass of the shoulder descends as a wedge, sinking into the flattened outer arm half way down.

At this point, from the front, the arm wedges downward to enter the forearm below the elbow. When the thumb is turned away from the body, the mass of the forearm is oval, becoming round when the bones of the forearm cross.

The mass corresponding to the wrist is twice as wide as it is thick and enters the forearm half way up, as a flattened wedge.

From the back, the shoulder enters the arm on the side. Beneath it there is a truncated wedge from the center of which, in a line from elbow to shoulder, is the plane of the tendon of the elbow. The forearm is rounded or oval, depending upon whether or not the bones of the forearm are crossed, and the wrist is twice as wide as it is thick.

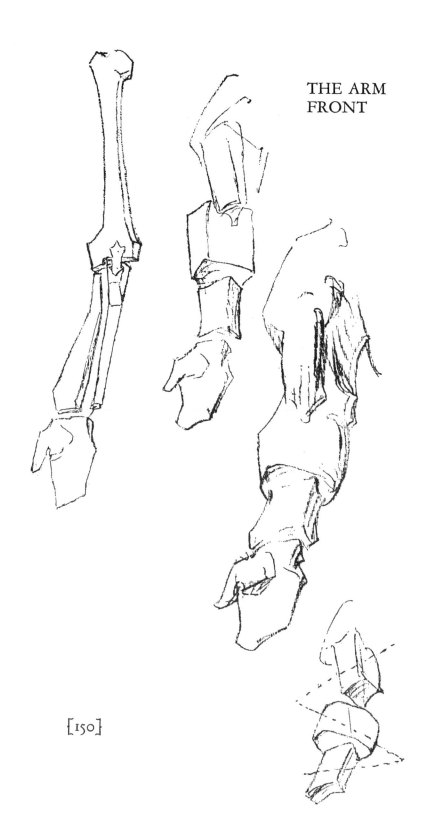

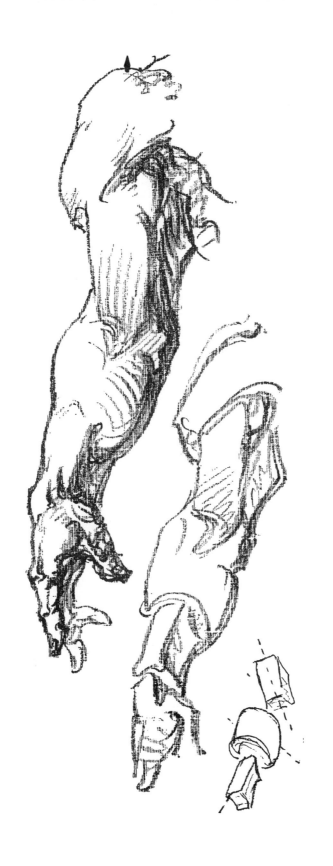

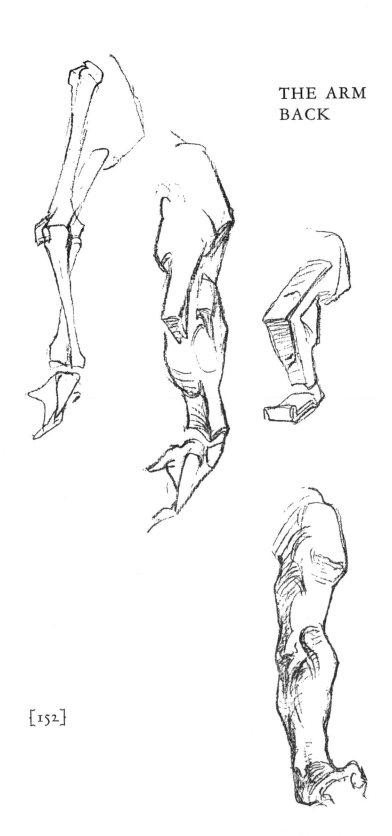

THE ARM
BACK

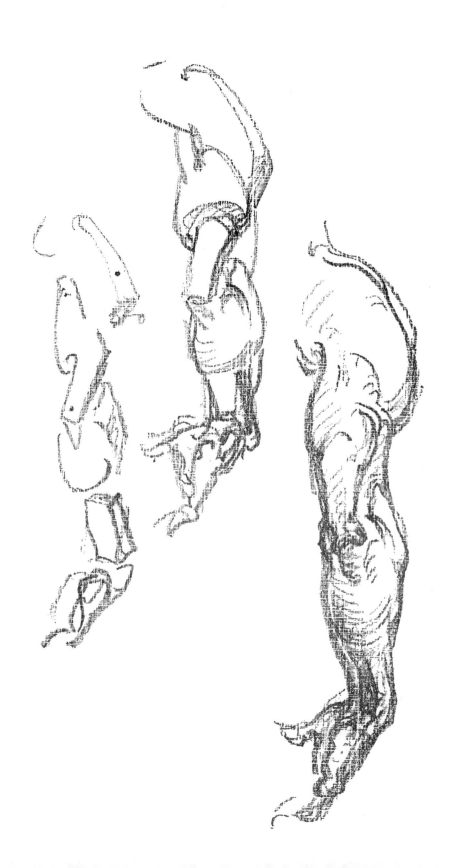

UPPER LIMBS

❦

The Hand

THE bones of the wrist are mortised with those of the hand, making one mass, the hand moving with the wrist. The width of the wrist is twice its thickness and where it joins the arm it diminishes in both width and thickness. There is always a step-down from the back of the arm, over the wrist, to the hand.

The wrist moves with the hand on the forearm, and in combination with these has some rotary movement, but no twisting movement. The twisting movement is accomplished by the forearm.

The hand has two masses: that of the hand proper, and that of the thumb.

The first of these masses is beveled from knuckles to wrist on the edge, from wrist to knuckles on the flat side, and from first to little finger from side to side. It is slightly arched across the back.

The knuckles are somewhat more arched. They are concentric around the base of the thumb, the second knuckle larger and higher than the rest, the first knuckle lower on its thumb side, where it has an overhang, as has also the knuckle of the little finger, due to their exposed positions.

On the little finger side, the form of the hand is given by the abductor muscle and the overhang of the knuckle, by which the curve of that side is carried well up to the middle of the first segment of the little finger.

[154]

On the back of the hand, nearly flat except in the clenched fist, the tendons of the long extensors are superficial, and may be raised sharply under the skin.

The hand had four primal uses: weapon, scoop, hook and tongs.

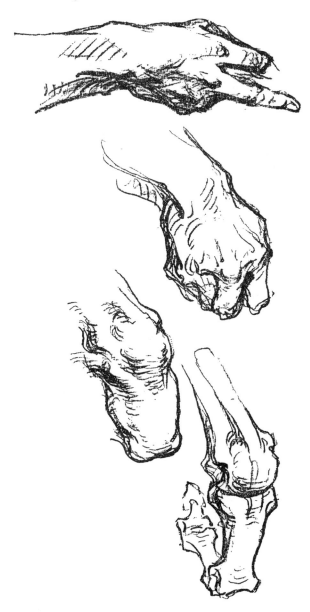

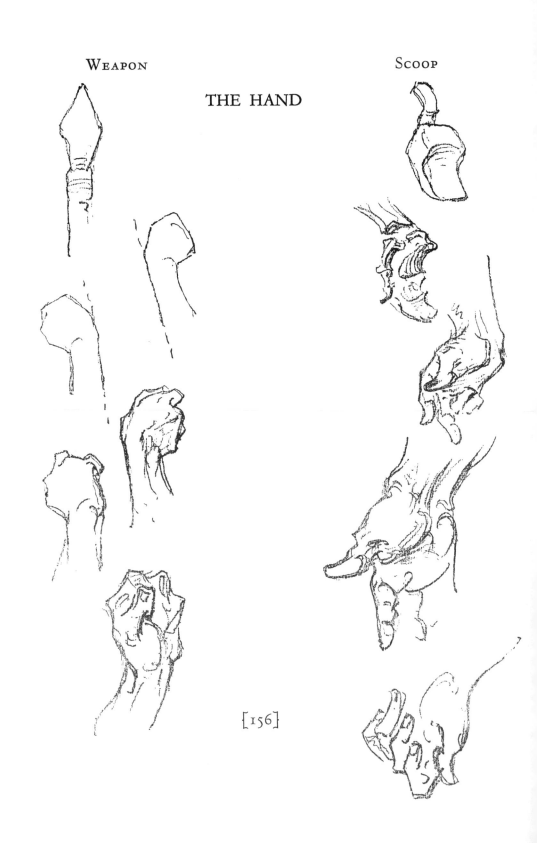

WEAPON

SCOOP

THE HAND

[156]

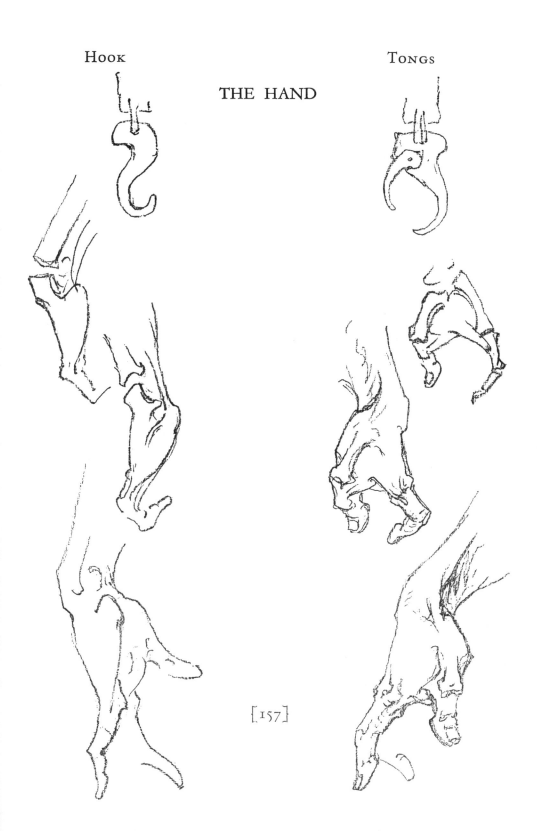

Hook

Tongs

THE HAND

[157]

❀

Fingers

THERE are three bones in each of the four fingers, called phalanges or soldiers. Each phalanx turns on the one above and leaves the end of the higher bone exposed. There are no muscles below the knuckles, but tendons traverse the fingers on the backs and tendons and pads cover the fronts. The longest and largest finger is the middle finger. In the clasped hand it is opposite the thumb and with it bears the chief burden. For the opposite reason the little finger is smallest and shortest and most freely movable.

The bones of the body are narrower in the shaft than at either end and this is especially true of the fingers. The joints are square, the shafts also are square, but smaller, and with rounded edges. The tips are triangular. The middle joint of each finger is the largest.

The masses of these segments are not placed end to end as on a dead center, either in profile or in back view. In the back view the fingers as a whole arch toward the middle finger.

In the profile view, there is a step-down from each segment to the one beyond, bridged by a wedge.

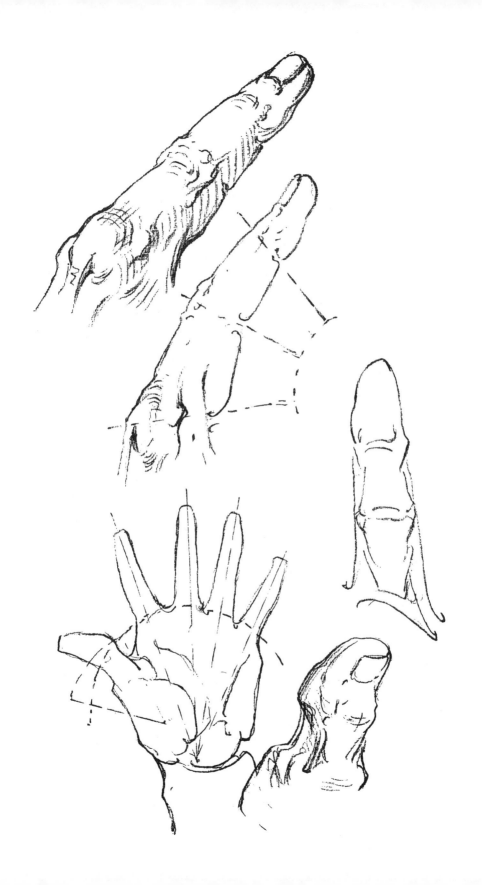

LOWER LIMBS

❦

Thigh & Leg

THE pelvic girdle, or basin, is in two pieces with a binding keystone, called the sacrum, at the back. Upon this keystone rests the spine. The lower limbs articulate from each side, causing the basin to tilt or rock with a rotary or churning movement. To allow this range of movement the lower limbs have a ball-and-socket joint.

The joint of the shoulder and that of the hips are both ball-and-socket joints, and they differ in form only so far as the movements executed by the upper and lower limbs differ. The cup in the joint of the shoulder blade is shallow; the socket into which the thigh bone fits is deeper and more solid. This is so because the mechanism pertaining to the movement of the lower limbs is designed to carry weight, for the lower limbs are supporting columns as well as means of locomotion. They have firmness as well as action.

The thigh bone ends at the knee as a hinge joint, the leg requiring only a backward and forward motion for which a hinge joint is sufficient. However, the joint at the knee is not formed as if by a bolt passing through the two parts of a hinge. Instead, the upper portion of the leg bone passes, or glides, under the lower end of the thigh bone. These are held in place by ligaments and sheathed with membrane. In this manner the ends of the bones are held together as they rock in their relative convexities and shallow concavities.

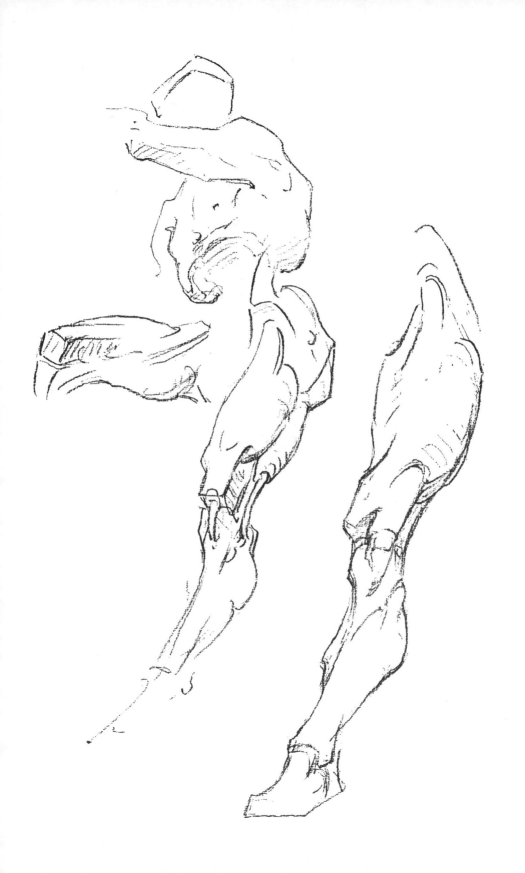

THIGH & LEG

The column of the thigh and leg diminishes in thickness as it descends to the foot. From any view it also has a reverse curve that extends its entire length.

On either side a descending wedge overlaps the rounded form of the thighs and this again overlaps the square form above and below the knee joint, which is also square. The leg at the calf is triangular, at the ankle it is square.

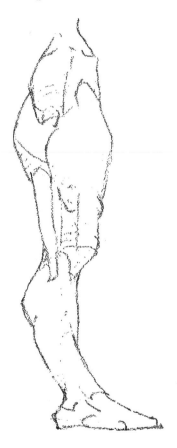

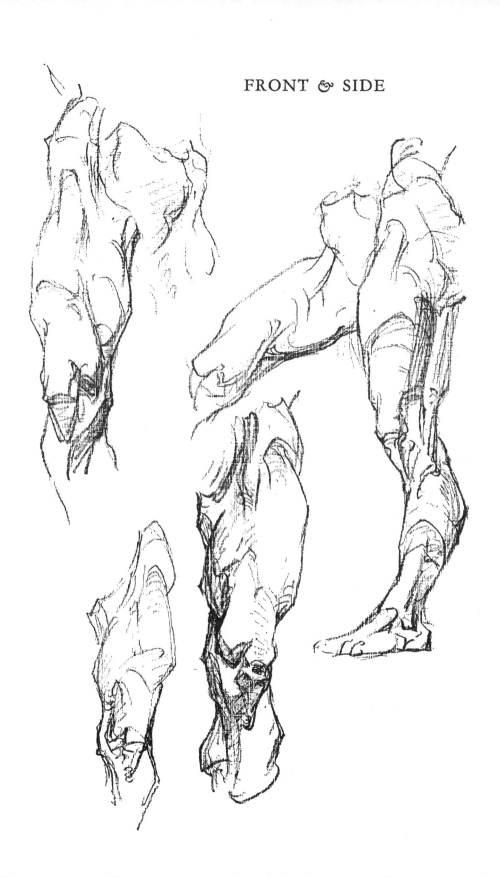

LOWER LIMBS

✿

Thigh & Leg—Back

From the back, the hips and the buttocks are square and overhang the pillars of the thighs. The thigh is rounded in form half way down to the knee, and then it becomes square to just below the knee. The calf of the leg is triangular and the ankle is square.

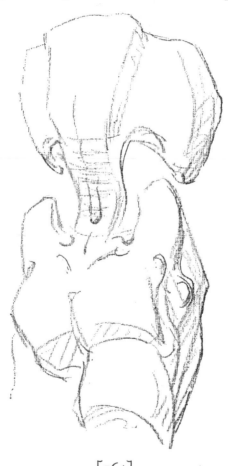

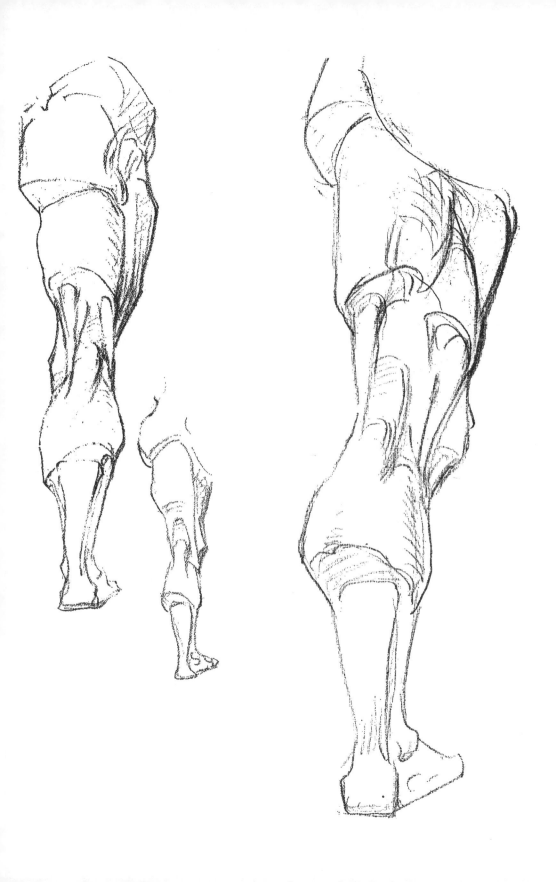

LOWER LIMBS

The Knee

THINK of the knee as a square with sides beveled forward, slightly hollowed in back and carrying the kneecap in front. When the knee is straight its bursa, or water mattress, forms a bulge on either side in the corner between the cap and its tendon, exactly opposite the joint itself. The kneecap is always above the level of the joint. The back of the knee, when bent, is hollowed by the hamstring tendons on either side. When straight, the bone becomes prominent between them, making, with these tendons, three knobs. The inside of the knee is larger, and the knee as a whole is bent convex towards its fellow. The hip socket, the knee and the ankle are all in line when the leg is straight, but the shaft of the thigh bone is carried some distance out by a long neck, so that the thigh is set at an angle with the leg.

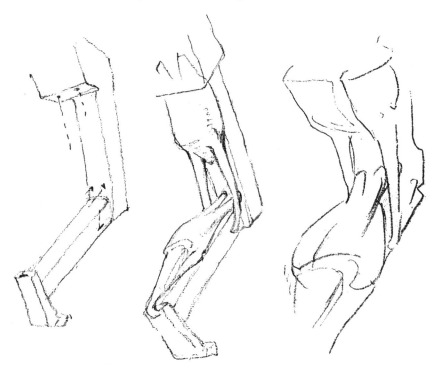

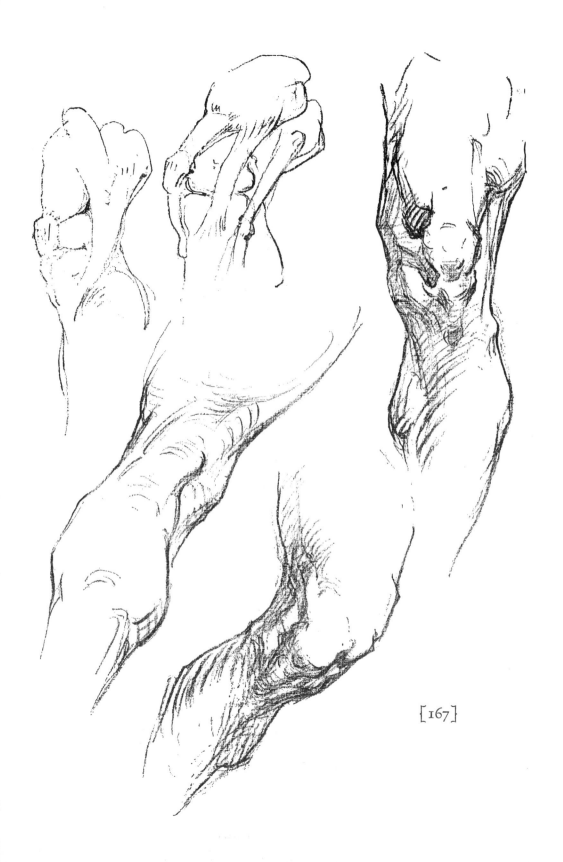

[167]

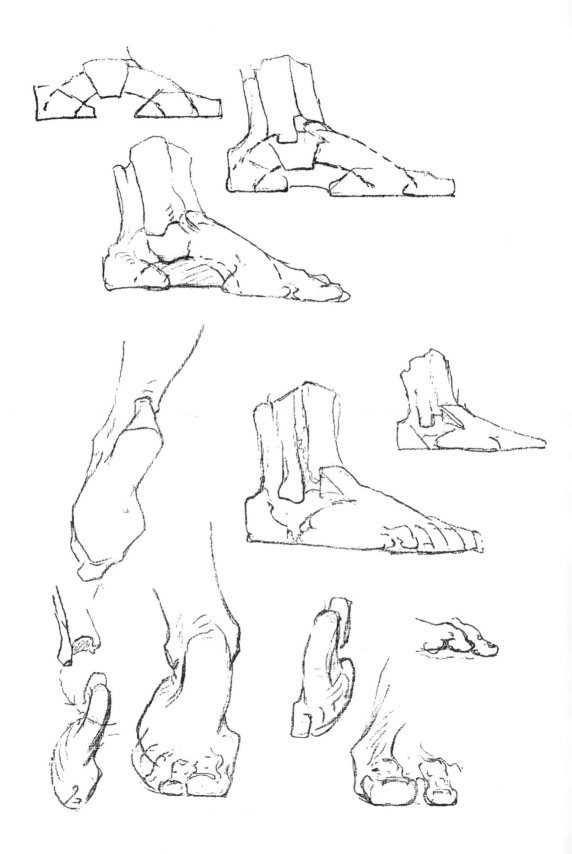

LOWER LIMBS

The Foot

THE two bones of the leg, called the tibia and the fibula, extend from the knee to the ankle. The lower ends of these bones project so as to form the inner and outer ankle joints, respectively, where they receive the articulating joint of the foot, the astragalus. The foot rolls under the leg bones. It is arched, and at each end of the arch it is buttressed either by heel or large toe. The keystone of this arch is not fixed; it moves freely between the two bones of the leg. The heel is on the outside of the foot, the ball of the large toe on the inside, giving it a rotary and a transverse movement crossing the already mentioned horizontal arch.

The bones of the foot are wedged together and bound by ligaments, giving resistance, solidity and elasticity.

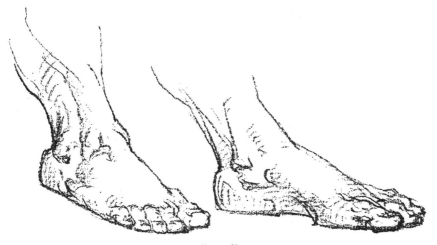

A CATALOG OF SELECTED
DOVER BOOKS
IN ALL FIELDS OF INTEREST

A CATALOG OF SELECTED DOVER
BOOKS IN ALL FIELDS OF INTEREST

CONCERNING THE SPIRITUAL IN ART, Wassily Kandinsky. Pioneering work by father of abstract art. Thoughts on color theory, nature of art. Analysis of earlier masters. 12 illustrations. 80pp. of text. 5⅜ x 8½. 23411-8 Pa. $4.95

ANIMALS: 1,419 Copyright-Free Illustrations of Mammals, Birds, Fish, Insects, etc., Jim Harter (ed.). Clear wood engravings present, in extremely lifelike poses, over 1,000 species of animals. One of the most extensive pictorial sourcebooks of its kind. Captions. Index. 284pp. 9 x 12. 23766-4 Pa. $14.95

CELTIC ART: The Methods of Construction, George Bain. Simple geometric techniques for making Celtic interlacements, spirals, Kells-type initials, animals, humans, etc. Over 500 illustrations. 160pp. 9 x 12. (USO) 22923-8 Pa. $9.95

AN ATLAS OF ANATOMY FOR ARTISTS, Fritz Schider. Most thorough reference work on art anatomy in the world. Hundreds of illustrations, including selections from works by Vesalius, Leonardo, Goya, Ingres, Michelangelo, others. 593 illustrations. 192pp. 7⅛ x 10¼. 20241-0 Pa. $9.95

CELTIC HAND STROKE-BY-STROKE (Irish Half-Uncial from "The Book of Kells"): An Arthur Baker Calligraphy Manual, Arthur Baker. Complete guide to creating each letter of the alphabet in distinctive Celtic manner. Covers hand position, strokes, pens, inks, paper, more. Illustrated. 48pp. 8¼ x 11. 24336-2 Pa. $3.95

EASY ORIGAMI, John Montroll. Charming collection of 32 projects (hat, cup, pelican, piano, swan, many more) specially designed for the novice origami hobbyist. Clearly illustrated easy-to-follow instructions insure that even beginning papercrafters will achieve successful results. 48pp. 8¼ x 11. 27298-2 Pa. $3.50

THE COMPLETE BOOK OF BIRDHOUSE CONSTRUCTION FOR WOOD-WORKERS, Scott D. Campbell. Detailed instructions, illustrations, tables. Also data on bird habitat and instinct patterns. Bibliography. 3 tables. 63 illustrations in 15 figures. 48pp. 5¼ x 8½. 24407-5 Pa. $2.50

BLOOMINGDALE'S ILLUSTRATED 1886 CATALOG: Fashions, Dry Goods and Housewares, Bloomingdale Brothers. Famed merchants' extremely rare catalog depicting about 1,700 products: clothing, housewares, firearms, dry goods, jewelry, more. Invaluable for dating, identifying vintage items. Also, copyright-free graphics for artists, designers. Co-published with Henry Ford Museum & Greenfield Village. 160pp. 8¼ x 11. 25780-0 Pa. $10.95

HISTORIC COSTUME IN PICTURES, Braun & Schneider. Over 1,450 costumed figures in clearly detailed engravings–from dawn of civilization to end of 19th century. Captions. Many folk costumes. 256pp. 8⅜ x 11¾. 23150-X Pa. $12.95

STICKLEY CRAFTSMAN FURNITURE CATALOGS, Gustav Stickley and L. & J. G. Stickley. Beautiful, functional furniture in two authentic catalogs from 1910. 594 illustrations, including 277 photos, show settles, rockers, armchairs, reclining chairs, bookcases, desks, tables. 183pp. 6½ x 9¼. 23838-5 Pa. $11.95

AMERICAN LOCOMOTIVES IN HISTORIC PHOTOGRAPHS: 1858 to 1949, Ron Ziel (ed.). A rare collection of 126 meticulously detailed official photographs, called "builder portraits," of American locomotives that majestically chronicle the rise of steam locomotive power in America. Introduction. Detailed captions. xi + 129pp. 9 x 12. 27393-8 Pa. $13.95

AMERICA'S LIGHTHOUSES: An Illustrated History, Francis Ross Holland, Jr. Delightfully written, profusely illustrated fact-filled survey of over 200 American lighthouses since 1716. History, anecdotes, technological advances, more. 240pp. 8 x 10¾. 25576-X Pa. $12.95

TOWARDS A NEW ARCHITECTURE, Le Corbusier. Pioneering manifesto by founder of "International School." Technical and aesthetic theories, views of industry, economics, relation of form to function, "mass-production split" and much more. Profusely illustrated. 320pp. 6⅛ x 9¼. (USO) 25023-7 Pa. $9.95

HOW THE OTHER HALF LIVES, Jacob Riis. Famous journalistic record, exposing poverty and degradation of New York slums around 1900, by major social reformer. 100 striking and influential photographs. 233pp. 10 x 7⅞. 22012-5 Pa. $11.95

FRUIT KEY AND TWIG KEY TO TREES AND SHRUBS, William M. Harlow. One of the handiest and most widely used identification aids. Fruit key covers 120 deciduous and evergreen species; twig key 160 deciduous species. Easily used. Over 300 photographs. 126pp. 5⅜ x 8½. 20511-8 Pa. $3.95

COMMON BIRD SONGS, Dr. Donald J. Borror. Songs of 60 most common U.S. birds: robins, sparrows, cardinals, bluejays, finches, more–arranged in order of increasing complexity. Up to 9 variations of songs of each species.
Cassette and manual 99911-4 $8.95

ORCHIDS AS HOUSE PLANTS, Rebecca Tyson Northen. Grow cattleyas and many other kinds of orchids–in a window, in a case, or under artificial light. 63 illustrations. 148pp. 5⅜ x 8½. 23261-1 Pa. $5.95

MONSTER MAZES, Dave Phillips. Masterful mazes at four levels of difficulty. Avoid deadly perils and evil creatures to find magical treasures. Solutions for all 32 exciting illustrated puzzles. 48pp. 8¼ x 11. 26005-4 Pa. $2.95

MOZART'S DON GIOVANNI (DOVER OPERA LIBRETTO SERIES), Wolfgang Amadeus Mozart. Introduced and translated by Ellen H. Bleiler. Standard Italian libretto, with complete English translation. Convenient and thoroughly portable–an ideal companion for reading along with a recording or the performance itself. Introduction. List of characters. Plot summary. 121pp. 5¼ x 8½.
24944-1 Pa. $3.95

TECHNICAL MANUAL AND DICTIONARY OF CLASSICAL BALLET, Gail Grant. Defines, explains, comments on steps, movements, poses and concepts. 15-page pictorial section. Basic book for student, viewer. 127pp. 5⅜ x 8½.
21843-0 Pa. $4.95

BRASS INSTRUMENTS: Their History and Development, Anthony Baines. Authoritative, updated survey of the evolution of trumpets, trombones, bugles, cornets, French horns, tubas and other brass wind instruments. Over 140 illustrations and 48 music examples. Corrected and updated by author. New preface. Bibliography. 320pp. 5⅜ x 8½. 27574-4 Pa. $9.95

HOLLYWOOD GLAMOR PORTRAITS, John Kobal (ed.). 145 photos from 1926-49. Harlow, Gable, Bogart, Bacall; 94 stars in all. Full background on photographers, technical aspects. 160pp. 8⅞ x 11¼. 23352-9 Pa. $12.95

MAX AND MORITZ, Wilhelm Busch. Great humor classic in both German and English. Also 10 other works: "Cat and Mouse," "Plisch and Plumm," etc. 216pp. 5⅜ x 8½. 20181-3 Pa. $6.95

THE RAVEN AND OTHER FAVORITE POEMS, Edgar Allan Poe. Over 40 of the author's most memorable poems: "The Bells," "Ulalume," "Israfel," "To Helen," "The Conqueror Worm," "Eldorado," "Annabel Lee," many more. Alphabetic lists of titles and first lines. 64pp. 5³/₁₆ x 8¼. 26685-0 Pa. $1.00

PERSONAL MEMOIRS OF U. S. GRANT, Ulysses Simpson Grant. Intelligent, deeply moving firsthand account of Civil War campaigns, considered by many the finest military memoirs ever written. Includes letters, historic photographs, maps and more. 528pp. 6⅛ x 9¼. 28587-1 Pa. $12.95

AMULETS AND SUPERSTITIONS, E. A. Wallis Budge. Comprehensive discourse on origin, powers of amulets in many ancient cultures: Arab, Persian Babylonian, Assyrian, Egyptian, Gnostic, Hebrew, Phoenician, Syriac, etc. Covers cross, swastika, crucifix, seals, rings, stones, etc. 584pp. 5⅜ x 8½. 23573-4 Pa. $15.95

RUSSIAN STORIES/PYCCKNE PACCKA3bI: A Dual-Language Book, edited by Gleb Struve. Twelve tales by such masters as Chekhov, Tolstoy, Dostoevsky, Pushkin, others. Excellent word-for-word English translations on facing pages, plus teaching and study aids, Russian/English vocabulary, biographical/critical introductions, more. 416pp. 5⅜ x 8½. 26244-8 Pa. $9.95

PHILADELPHIA THEN AND NOW: 60 Sites Photographed in the Past and Present, Kenneth Finkel and Susan Oyama. Rare photographs of City Hall, Logan Square, Independence Hall, Betsy Ross House, other landmarks juxtaposed with contemporary views. Captures changing face of historic city. Introduction. Captions. 128pp. 8¼ x 11. 25790-8 Pa. $9.95

AIA ARCHITECTURAL GUIDE TO NASSAU AND SUFFOLK COUNTIES, LONG ISLAND, The American Institute of Architects, Long Island Chapter, and the Society for the Preservation of Long Island Antiquities. Comprehensive, well-researched and generously illustrated volume brings to life over three centuries of Long Island's great architectural heritage. More than 240 photographs with authoritative, extensively detailed captions. 176pp. 8¼ x 11. 26946-9 Pa. $14.95

NORTH AMERICAN INDIAN LIFE: Customs and Traditions of 23 Tribes, Elsie Clews Parsons (ed.). 27 fictionalized essays by noted anthropologists examine religion, customs, government, additional facets of life among the Winnebago, Crow, Zuni, Eskimo, other tribes. 480pp. 6⅛ x 9¼. 27377-6 Pa. $10.95

FRANK LLOYD WRIGHT'S HOLLYHOCK HOUSE, Donald Hoffmann. Lavishly illustrated, carefully documented study of one of Wright's most controversial residential designs. Over 120 photographs, floor plans, elevations, etc. Detailed perceptive text by noted Wright scholar. Index. 128pp. 9¼ x 10¾. 27133-1 Pa. $11.95

THE MALE AND FEMALE FIGURE IN MOTION: 60 Classic Photographic Sequences, Eadweard Muybridge. 60 true-action photographs of men and women walking, running, climbing, bending, turning, etc., reproduced from rare 19th-century masterpiece. vi + 121pp. 9 x 12. 24745-7 Pa. $10.95

1001 QUESTIONS ANSWERED ABOUT THE SEASHORE, N. J. Berrill and Jacquelyn Berrill. Queries answered about dolphins, sea snails, sponges, starfish, fishes, shore birds, many others. Covers appearance, breeding, growth, feeding, much more. 305pp. 5¼ x 8¼. 23366-9 Pa. $9.95

GUIDE TO OWL WATCHING IN NORTH AMERICA, Donald S. Heintzelman. Superb guide offers complete data and descriptions of 19 species: barn owl, screech owl, snowy owl, many more. Expert coverage of owl-watching equipment, conservation, migrations and invasions, etc. Guide to observing sites. 84 illustrations. xiii + 193pp. 5⅜ x 8½. 27344-X Pa. $8.95

MEDICINAL AND OTHER USES OF NORTH AMERICAN PLANTS: A Historical Survey with Special Reference to the Eastern Indian Tribes, Charlotte Erichsen-Brown. Chronological historical citations document 500 years of usage of plants, trees, shrubs native to eastern Canada, northeastern U.S. Also complete identifying information. 343 illustrations. 544pp. 6½ x 9¼. 25951-X Pa. $12.95

STORYBOOK MAZES, Dave Phillips. 23 stories and mazes on two-page spreads: Wizard of Oz, Treasure Island, Robin Hood, etc. Solutions. 64pp. 8¼ x 11. 23628-5 Pa. $2.95

NEGRO FOLK MUSIC, U.S.A., Harold Courlander. Noted folklorist's scholarly yet readable analysis of rich and varied musical tradition. Includes authentic versions of over 40 folk songs. Valuable bibliography and discography. xi + 324pp. 5⅜ x 8½. 27350-4 Pa. $9.95

MOVIE-STAR PORTRAITS OF THE FORTIES, John Kobal (ed.). 163 glamor, studio photos of 106 stars of the 1940s: Rita Hayworth, Ava Gardner, Marlon Brando, Clark Gable, many more. 176pp. 8⅜ x 11¼. 23546-7 Pa. $14.95

BENCHLEY LOST AND FOUND, Robert Benchley. Finest humor from early 30s, about pet peeves, child psychologists, post office and others. Mostly unavailable elsewhere. 73 illustrations by Peter Arno and others. 183pp. 5⅜ x 8½. 22410-4 Pa. $6.95

YEKL and THE IMPORTED BRIDEGROOM AND OTHER STORIES OF YIDDISH NEW YORK, Abraham Cahan. Film Hester Street based on Yekl (1896). Novel, other stories among first about Jewish immigrants on N.Y.'s East Side. 240pp. 5⅜ x 8½. 22427-9 Pa. $6.95

SELECTED POEMS, Walt Whitman. Generous sampling from *Leaves of Grass*. Twenty-four poems include "I Hear America Singing," "Song of the Open Road," "I Sing the Body Electric," "When Lilacs Last in the Dooryard Bloom'd," "O Captain! My Captain!"–all reprinted from an authoritative edition. Lists of titles and first lines. 128pp. 5⁵⁄₁₆ x 8¼. 26878-0 Pa. $1.00

THE BEST TALES OF HOFFMANN, E. T. A. Hoffmann. 10 of Hoffmann's most important stories: "Nutcracker and the King of Mice," "The Golden Flowerpot," etc. 458pp. 5⅜ x 8½. 21793-0 Pa. $9.95

FROM FETISH TO GOD IN ANCIENT EGYPT, E. A. Wallis Budge. Rich detailed survey of Egyptian conception of "God" and gods, magic, cult of animals, Osiris, more. Also, superb English translations of hymns and legends. 240 illustrations. 545pp. 5⅜ x 8½. 25803-3 Pa. $13.95

FRENCH STORIES/CONTES FRANÇAIS: A Dual-Language Book, Wallace Fowlie. Ten stories by French masters, Voltaire to Camus: "Micromegas" by Voltaire; "The Atheist's Mass" by Balzac; "Minuet" by de Maupassant; "The Guest" by Camus, six more. Excellent English translations on facing pages. Also French-English vocabulary list, exercises, more. 352pp. 5⅜ x 8½. 26443-2 Pa. $9.95

CHICAGO AT THE TURN OF THE CENTURY IN PHOTOGRAPHS: 122 Historic Views from the Collections of the Chicago Historical Society, Larry A. Viskochil. Rare large-format prints offer detailed views of City Hall, State Street, the Loop, Hull House, Union Station, many other landmarks, circa 1904-1913. Introduction. Captions. Maps. 144pp. 9⅜ x 12¼. 24656-6 Pa. $12.95

OLD BROOKLYN IN EARLY PHOTOGRAPHS, 1865-1929, William Lee Younger. Luna Park, Gravesend race track, construction of Grand Army Plaza, moving of Hotel Brighton, etc. 157 previously unpublished photographs. 165pp. 8⅜ x 11¾. 23587-4 Pa. $13.95

THE MYTHS OF THE NORTH AMERICAN INDIANS, Lewis Spence. Rich anthology of the myths and legends of the Algonquins, Iroquois, Pawnees and Sioux, prefaced by an extensive historical and ethnological commentary. 36 illustrations. 480pp. 5⅜ x 8½. 25967-6 Pa. $10.95

AN ENCYCLOPEDIA OF BATTLES: Accounts of Over 1,560 Battles from 1479 B.C. to the Present, David Eggenberger. Essential details of every major battle in recorded history from the first battle of Megiddo in 1479 B.C. to Grenada in 1984. List of Battle Maps. New Appendix covering the years 1967-1984. Index. 99 illustrations. 544pp. 6½ x 9¼. 24913-1 Pa. $16.95

SAILING ALONE AROUND THE WORLD, Captain Joshua Slocum. First man to sail around the world, alone, in small boat. One of great feats of seamanship told in delightful manner. 67 illustrations. 294pp. 5⅜ x 8½. 20326-3 Pa. $6.95

ANARCHISM AND OTHER ESSAYS, Emma Goldman. Powerful, penetrating, prophetic essays on direct action, role of minorities, prison reform, puritan hypocrisy, violence, etc. 271pp. 5⅜ x 8½. 22484-8 Pa. $7.95

MYTHS OF THE HINDUS AND BUDDHISTS, Ananda K. Coomaraswamy and Sister Nivedita. Great stories of the epics; deeds of Krishna, Shiva, taken from puranas, Vedas, folk tales; etc. 32 illustrations. 400pp. 5⅜ x 8½. 21759-0 Pa. $12.95

BEYOND PSYCHOLOGY, Otto Rank. Fear of death, desire of immortality, nature of sexuality, social organization, creativity, according to Rankian system. 291pp. 5⅜ x 8½. 20485-5 Pa. $8.95

A THEOLOGICO-POLITICAL TREATISE, Benedict Spinoza. Also contains unfinished Political Treatise. Great classic on religious liberty, theory of government on common consent. R. Elwes translation. Total of 421pp. 5⅜ x 8½. 20249-6 Pa. $9.95

MY BONDAGE AND MY FREEDOM, Frederick Douglass. Born a slave, Douglass became outspoken force in antislavery movement. The best of Douglass' autobiographies. Graphic description of slave life. 464pp. 5⅜ x 8½. 22457-0 Pa. $8.95

FOLLOWING THE EQUATOR: A Journey Around the World, Mark Twain. Fascinating humorous account of 1897 voyage to Hawaii, Australia, India, New Zealand, etc. Ironic, bemused reports on peoples, customs, climate, flora and fauna, politics, much more. 197 illustrations. 720pp. 5⅜ x 8½. 26113-1 Pa. $15.95

THE PEOPLE CALLED SHAKERS, Edward D. Andrews. Definitive study of Shakers: origins, beliefs, practices, dances, social organization, furniture and crafts, etc. 33 illustrations. 351pp. 5⅜ x 8½. 21081-2 Pa. $8.95

THE MYTHS OF GREECE AND ROME, H. A. Guerber. A classic of mythology, generously illustrated, long prized for its simple, graphic, accurate retelling of the principal myths of Greece and Rome, and for its commentary on their origins and significance. With 64 illustrations by Michelangelo, Raphael, Titian, Rubens, Canova, Bernini and others. 480pp. 5⅜ x 8½. 27584-1 Pa. $9.95

PSYCHOLOGY OF MUSIC, Carl E. Seashore. Classic work discusses music as a medium from psychological viewpoint. Clear treatment of physical acoustics, auditory apparatus, sound perception, development of musical skills, nature of musical feeling, host of other topics. 88 figures. 408pp. 5⅜ x 8½. 21851-1 Pa. $11.95

THE PHILOSOPHY OF HISTORY, Georg W. Hegel. Great classic of Western thought develops concept that history is not chance but rational process, the evolution of freedom. 457pp. 5⅜ x 8½. 20112-0 Pa. $9.95

THE BOOK OF TEA, Kakuzo Okakura. Minor classic of the Orient: entertaining, charming explanation, interpretation of traditional Japanese culture in terms of tea ceremony. 94pp. 5⅜ x 8½. 20070-1 Pa. $3.95

LIFE IN ANCIENT EGYPT, Adolf Erman. Fullest, most thorough, detailed older account with much not in more recent books, domestic life, religion, magic, medicine, commerce, much more. Many illustrations reproduce tomb paintings, carvings, hieroglyphs, etc. 597pp. 5⅜ x 8½. 22632-8 Pa. $12.95

SUNDIALS, Their Theory and Construction, Albert Waugh. Far and away the best, most thorough coverage of ideas, mathematics concerned, types, construction, adjusting anywhere. Simple, nontechnical treatment allows even children to build several of these dials. Over 100 illustrations. 230pp. 5⅜ x 8½. 22947-5 Pa. $8.95

DYNAMICS OF FLUIDS IN POROUS MEDIA, Jacob Bear. For advanced students of ground water hydrology, soil mechanics and physics, drainage and irrigation engineering, and more. 335 illustrations. Exercises, with answers. 784pp. 6⅛ x 9¼. 65675-6 Pa. $19.95

SONGS OF EXPERIENCE: Facsimile Reproduction with 26 Plates in Full Color, William Blake. 26 full-color plates from a rare 1826 edition. Includes "The Tyger," "London," "Holy Thursday," and other poems. Printed text of poems. 48pp. 5¼ x 7. 24636-1 Pa. $4.95

OLD-TIME VIGNETTES IN FULL COLOR, Carol Belanger Grafton (ed.). Over 390 charming, often sentimental illustrations, selected from archives of Victorian graphics—pretty women posing, children playing, food, flowers, kittens and puppies, smiling cherubs, birds and butterflies, much more. All copyright-free. 48pp. 9¼ x 12¼. 27269-9 Pa. $7.95

PERSPECTIVE FOR ARTISTS, Rex Vicat Cole. Depth, perspective of sky and sea, shadows, much more, not usually covered. 391 diagrams, 81 reproductions of drawings and paintings. 279pp. 5⅜ x 8½. 22487-2 Pa. $7.95

DRAWING THE LIVING FIGURE, Joseph Sheppard. Innovative approach to artistic anatomy focuses on specifics of surface anatomy, rather than muscles and bones. Over 170 drawings of live models in front, back and side views, and in widely varying poses. Accompanying diagrams. 177 illustrations. Introduction. Index. 144pp. 8⅜ x11¼. 26723-7 Pa. $8.95

GOTHIC AND OLD ENGLISH ALPHABETS: 100 Complete Fonts, Dan X. Solo. Add power, elegance to posters, signs, other graphics with 100 stunning copyright-free alphabets: Blackstone, Dolbey, Germania, 97 more—including many lower-case, numerals, punctuation marks. 104pp. 8⅛ x 11. 24695-7 Pa. $8.95

HOW TO DO BEADWORK, Mary White. Fundamental book on craft from simple projects to five-bead chains and woven works. 106 illustrations. 142pp. 5⅜ x 8.
 20697-1 Pa. $5.95

THE BOOK OF WOOD CARVING, Charles Marshall Sayers. Finest book for beginners discusses fundamentals and offers 34 designs. "Absolutely first rate . . . well thought out and well executed."–E. J. Tangerman. 118pp. 7¾ x 10⅝.
 23654-4 Pa. $7.95

ILLUSTRATED CATALOG OF CIVIL WAR MILITARY GOODS: Union Army Weapons, Insignia, Uniform Accessories, and Other Equipment, Schuyler, Hartley, and Graham. Rare, profusely illustrated 1846 catalog includes Union Army uniform and dress regulations, arms and ammunition, coats, insignia, flags, swords, rifles, etc. 226 illustrations. 160pp. 9 x 12. 24939-5 Pa. $10.95

WOMEN'S FASHIONS OF THE EARLY 1900s: An Unabridged Republication of "New York Fashions, 1909," National Cloak & Suit Co. Rare catalog of mail-order fashions documents women's and children's clothing styles shortly after the turn of the century. Captions offer full descriptions, prices. Invaluable resource for fashion, costume historians. Approximately 725 illustrations. 128pp. 8⅜ x 11¼.
 27276-1 Pa. $11.95

THE 1912 AND 1915 GUSTAV STICKLEY FURNITURE CATALOGS, Gustav Stickley. With over 200 detailed illustrations and descriptions, these two catalogs are essential reading and reference materials and identification guides for Stickley furniture. Captions cite materials, dimensions and prices. 112pp. 6½ x 9¼.
 26676-1 Pa. $9.95

EARLY AMERICAN LOCOMOTIVES, John H. White, Jr. Finest locomotive engravings from early 19th century: historical (1804–74), main-line (after 1870), special, foreign, etc. 147 plates. 142pp. 11⅜ x 8¼. 22772-3 Pa. $10.95

THE TALL SHIPS OF TODAY IN PHOTOGRAPHS, Frank O. Braynard. Lavishly illustrated tribute to nearly 100 majestic contemporary sailing vessels: Amerigo Vespucci, Clearwater, Constitution, Eagle, Mayflower, Sea Cloud, Victory, many more. Authoritative captions provide statistics, background on each ship. 190 black-and-white photographs and illustrations. Introduction. 128pp. 8⅞ x 11¾.
 27163-3 Pa. $14.95

EARLY NINETEENTH-CENTURY CRAFTS AND TRADES, Peter Stockham (ed.). Extremely rare 1807 volume describes to youngsters the crafts and trades of the day: brickmaker, weaver, dressmaker, bookbinder, ropemaker, saddler, many more. Quaint prose, charming illustrations for each craft. 20 black-and-white line illustrations. 192pp. 4⅝ x 6. 27293-1 Pa. $4.95

VICTORIAN FASHIONS AND COSTUMES FROM HARPER'S BAZAR, 1867–1898, Stella Blum (ed.). Day costumes, evening wear, sports clothes, shoes, hats, other accessories in over 1,000 detailed engravings. 320pp. 9⅜ x 12¼.
22990-4 Pa. $15.95

GUSTAV STICKLEY, THE CRAFTSMAN, Mary Ann Smith. Superb study surveys broad scope of Stickley's achievement, especially in architecture. Design philosophy, rise and fall of the Craftsman empire, descriptions and floor plans for many Craftsman houses, more. 86 black-and-white halftones. 31 line illustrations. Introduction 208pp. 6½ x 9¼. 27210-9 Pa. $9.95

THE LONG ISLAND RAIL ROAD IN EARLY PHOTOGRAPHS, Ron Ziel. Over 220 rare photos, informative text document origin (1844) and development of rail service on Long Island. Vintage views of early trains, locomotives, stations, passengers, crews, much more. Captions. 8⅞ x 11¾. 26301-0 Pa. $13.95

THE BOOK OF OLD SHIPS: From Egyptian Galleys to Clipper Ships, Henry B. Culver. Superb, authoritative history of sailing vessels, with 80 magnificent line illustrations. Galley, bark, caravel, longship, whaler, many more. Detailed, informative text on each vessel by noted naval historian. Introduction. 256pp. 5⅜ x 8½.
27332-6 Pa. $7.95

TEN BOOKS ON ARCHITECTURE, Vitruvius. The most important book ever written on architecture. Early Roman aesthetics, technology, classical orders, site selection, all other aspects. Morgan translation. 331pp. 5⅜ x 8½. 20645-9 Pa. $8.95

THE HUMAN FIGURE IN MOTION, Eadweard Muybridge. More than 4,500 stopped-action photos, in action series, showing undraped men, women, children jumping, lying down, throwing, sitting, wrestling, carrying, etc. 390pp. 7⅞ x 10⅝.
20204-6 Clothbd. $27.95

TREES OF THE EASTERN AND CENTRAL UNITED STATES AND CANADA, William M. Harlow. Best one-volume guide to 140 trees. Full descriptions, woodlore, range, etc. Over 600 illustrations. Handy size. 288pp. 4½ x 6⅜.
20395-6 Pa. $6.95

SONGS OF WESTERN BIRDS, Dr. Donald J. Borror. Complete song and call repertoire of 60 western species, including flycatchers, juncoes, cactus wrens, many more—includes fully illustrated booklet. Cassette and manual 99913-0 $8.95

GROWING AND USING HERBS AND SPICES, Milo Miloradovich. Versatile handbook provides all the information needed for cultivation and use of all the herbs and spices available in North America. 4 illustrations. Index. Glossary. 236pp. 5⅜ x 8½.
25058-X Pa. $7.95

BIG BOOK OF MAZES AND LABYRINTHS, Walter Shepherd. 50 mazes and labyrinths in all—classical, solid, ripple, and more—in one great volume. Perfect inexpensive puzzler for clever youngsters. Full solutions. 112pp. 8⅛ x 11.
22951-3 Pa. $4.95

PIANO TUNING, J. Cree Fischer. Clearest, best book for beginner, amateur. Simple repairs, raising dropped notes, tuning by easy method of flattened fifths. No previous skills needed. 4 illustrations. 201pp. 5⅜ x 8½. 23267-0 Pa. $6.95

A SOURCE BOOK IN THEATRICAL HISTORY, A. M. Nagler. Contemporary observers on acting, directing, make-up, costuming, stage props, machinery, scene design, from Ancient Greece to Chekhov. 611pp. 5⅜ x 8½. 20515-0 Pa. $12.95

THE COMPLETE NONSENSE OF EDWARD LEAR, Edward Lear. All nonsense limericks, zany alphabets, Owl and Pussycat, songs, nonsense botany, etc., illustrated by Lear. Total of 320pp. 5⅜ x 8½. (USO) 20167-8 Pa. $7.95

VICTORIAN PARLOUR POETRY: An Annotated Anthology, Michael R. Turner. 117 gems by Longfellow, Tennyson, Browning, many lesser-known poets. "The Village Blacksmith," "Curfew Must Not Ring Tonight," "Only a Baby Small," dozens more, often difficult to find elsewhere. Index of poets, titles, first lines. xxiii + 325pp. 5⅜ x 8¼. 27044-0 Pa. $8.95

DUBLINERS, James Joyce. Fifteen stories offer vivid, tightly focused observations of the lives of Dublin's poorer classes. At least one, "The Dead," is considered a masterpiece. Reprinted complete and unabridged from standard edition. 160pp. 5³⁄₁₆ x 8¼. 26870-5 Pa. $1.00

THE HAUNTED MONASTERY and THE CHINESE MAZE MURDERS, Robert van Gulik. Two full novels by van Gulik, set in 7th-century China, continue adventures of Judge Dee and his companions. An evil Taoist monastery, seemingly supernatural events; overgrown topiary maze hides strange crimes. 27 illustrations. 328pp. 5⅜ x 8½. 23502-5 Pa. $8.95

THE BOOK OF THE SACRED MAGIC OF ABRAMELIN THE MAGE, translated by S. MacGregor Mathers. Medieval manuscript of ceremonial magic. Basic document in Aleister Crowley, Golden Dawn groups. 268pp. 5⅜ x 8½.
23211-5 Pa. $9.95

NEW RUSSIAN-ENGLISH AND ENGLISH-RUSSIAN DICTIONARY, M. A. O'Brien. This is a remarkably handy Russian dictionary, containing a surprising amount of information, including over 70,000 entries. 366pp. 4½ x 6⅛.
20208-9 Pa. $10.95

HISTORIC HOMES OF THE AMERICAN PRESIDENTS, Second, Revised Edition, Irvin Haas. A traveler's guide to American Presidential homes, most open to the public, depicting and describing homes occupied by every American President from George Washington to George Bush. With visiting hours, admission charges, travel routes. 175 photographs. Index. 160pp. 8¼ x 11. 26751-2 Pa. $11.95

NEW YORK IN THE FORTIES, Andreas Feininger. 162 brilliant photographs by the well-known photographer, formerly with *Life* magazine. Commuters, shoppers, Times Square at night, much else from city at its peak. Captions by John von Hartz. 181pp. 9¼ x 10¾. 23585-8 Pa. $13.95

INDIAN SIGN LANGUAGE, William Tomkins. Over 525 signs developed by Sioux and other tribes. Written instructions and diagrams. Also 290 pictographs. 111pp. 6⅛ x 9¼. 22029-X Pa. $3.95

ANATOMY: A Complete Guide for Artists, Joseph Sheppard. A master of figure drawing shows artists how to render human anatomy convincingly. Over 460 illustrations. 224pp. 8⅜ x 11¼. 27279-6 Pa. $11.95

MEDIEVAL CALLIGRAPHY: Its History and Technique, Marc Drogin. Spirited history, comprehensive instruction manual covers 13 styles (ca. 4th century thru 15th). Excellent photographs; directions for duplicating medieval techniques with modern tools. 224pp. 8⅜ x 11¼. 26142-5 Pa. $12.95

DRIED FLOWERS: How to Prepare Them, Sarah Whitlock and Martha Rankin. Complete instructions on how to use silica gel, meal and borax, perlite aggregate, sand and borax, glycerine and water to create attractive permanent flower arrangements. 12 illustrations. 32pp. 5⅜ x 8½. 21802-3 Pa. $1.00

EASY-TO-MAKE BIRD FEEDERS FOR WOODWORKERS, Scott D. Campbell. Detailed, simple-to-use guide for designing, constructing, caring for and using feeders. Text, illustrations for 12 classic and contemporary designs. 96pp. 5⅜ x 8½. 25847-5 Pa. $3.95

SCOTTISH WONDER TALES FROM MYTH AND LEGEND, Donald A. Mackenzie. 16 lively tales tell of giants rumbling down mountainsides, of a magic wand that turns stone pillars into warriors, of gods and goddesses, evil hags, powerful forces and more. 240pp. 5⅜ x 8½. 29677-6 Pa. $6.95

THE HISTORY OF UNDERCLOTHES, C. Willett Cunnington and Phyllis Cunnington. Fascinating, well-documented survey covering six centuries of English undergarments, enhanced with over 100 illustrations: 12th-century laced-up bodice, footed long drawers (1795), 19th-century bustles, 19th-century corsets for men, Victorian "bust improvers," much more. 272pp. 5⅜ x 8¼. 27124-2 Pa. $9.95

ARTS AND CRAFTS FURNITURE: The Complete Brooks Catalog of 1912, Brooks Manufacturing Co. Photos and detailed descriptions of more than 150 now very collectible furniture designs from the Arts and Crafts movement depict davenports, settees, buffets, desks, tables, chairs, bedsteads, dressers and more, all built of solid, quarter-sawed oak. Invaluable for students and enthusiasts of antiques, Americana and the decorative arts. 80pp. 6½ x 9¼. 27471-3 Pa. $8.95

HOW WE INVENTED THE AIRPLANE: An Illustrated History, Orville Wright. Fascinating firsthand account covers early experiments, construction of planes and motors, first flights, much more. Introduction and commentary by Fred C. Kelly. 76 photographs. 96pp. 8¼ x 11. 25662-6 Pa. $8.95

THE ARTS OF THE SAILOR: Knotting, Splicing and Ropework, Hervey Garrett Smith. Indispensable shipboard reference covers tools, basic knots and useful hitches; handsewing and canvas work, more. Over 100 illustrations. Delightful reading for sea lovers. 256pp. 5⅜ x 8½. 26440-8 Pa. $8.95

FRANK LLOYD WRIGHT'S FALLINGWATER: The House and Its History, Second, Revised Edition, Donald Hoffmann. A total revision–both in text and illustrations–of the standard document on Fallingwater, the boldest, most personal architectural statement of Wright's mature years, updated with valuable new material from the recently opened Frank Lloyd Wright Archives. "Fascinating"–*The New York Times*. 116 illustrations. 128pp. 9¼ x 10¾. 27430-6 Pa. $12.95

PHOTOGRAPHIC SKETCHBOOK OF THE CIVIL WAR, Alexander Gardner. 100 photos taken on field during the Civil War. Famous shots of Manassas Harper's Ferry, Lincoln, Richmond, slave pens, etc. 244pp. 10⅝ x 8¼. 22731-6 Pa. $10.95

FIVE ACRES AND INDEPENDENCE, Maurice G. Kains. Great back-to-the-land classic explains basics of self-sufficient farming. The one book to get. 95 illustrations. 397pp. 5⅜ x 8½. 20974-1 Pa. $7.95

SONGS OF EASTERN BIRDS, Dr. Donald J. Borror. Songs and calls of 60 species most common to eastern U.S.: warblers, woodpeckers, flycatchers, thrushes, larks, many more in high-quality recording. Cassette and manual 99912-2 $9.95

A MODERN HERBAL, Margaret Grieve. Much the fullest, most exact, most useful compilation of herbal material. Gigantic alphabetical encyclopedia, from aconite to zedoary, gives botanical information, medical properties, folklore, economic uses, much else. Indispensable to serious reader. 161 illustrations. 888pp. 6½ x 9¼. 2-vol. set. (USO) Vol. I: 22798-7 Pa. $9.95
 Vol. II: 22799-5 Pa. $9.95

HIDDEN TREASURE MAZE BOOK, Dave Phillips. Solve 34 challenging mazes accompanied by heroic tales of adventure. Evil dragons, people-eating plants, blood-thirsty giants, many more dangerous adversaries lurk at every twist and turn. 34 mazes, stories, solutions. 48pp. 8¼ x 11. 24566-7 Pa. $2.95

LETTERS OF W. A. MOZART, Wolfgang A. Mozart. Remarkable letters show bawdy wit, humor, imagination, musical insights, contemporary musical world; includes some letters from Leopold Mozart. 276pp. 5⅜ x 8½. 22859-2 Pa. $7.95

BASIC PRINCIPLES OF CLASSICAL BALLET, Agrippina Vaganova. Great Russian theoretician, teacher explains methods for teaching classical ballet. 118 illustrations. 175pp. 5⅜ x 8½. 22036-2 Pa. $5.95

THE JUMPING FROG, Mark Twain. Revenge edition. The original story of The Celebrated Jumping Frog of Calaveras County, a hapless French translation, and Twain's hilarious "retranslation" from the French. 12 illustrations. 66pp. 5⅜ x 8½. 22686-7 Pa. $3.95

BEST REMEMBERED POEMS, Martin Gardner (ed.). The 126 poems in this superb collection of 19th- and 20th-century British and American verse range from Shelley's "To a Skylark" to the impassioned "Renascence" of Edna St. Vincent Millay and to Edward Lear's whimsical "The Owl and the Pussycat." 224pp. 5⅜ x 8½. 27165-X Pa. $5.95

COMPLETE SONNETS, William Shakespeare. Over 150 exquisite poems deal with love, friendship, the tyranny of time, beauty's evanescence, death and other themes in language of remarkable power, precision and beauty. Glossary of archaic terms. 80pp. 5³⁄₁₆ x 8¼. 26686-9 Pa. $1.00

BODIES IN A BOOKSHOP, R. T. Campbell. Challenging mystery of blackmail and murder with ingenious plot and superbly drawn characters. In the best tradition of British suspense fiction. 192pp. 5⅜ x 8½. 24720-1 Pa. $6.95

THE WIT AND HUMOR OF OSCAR WILDE, Alvin Redman (ed.). More than 1,000 ripostes, paradoxes, wisecracks: Work is the curse of the drinking classes; I can resist everything except temptation; etc. 258pp. 5⅜ x 8½. 20602-5 Pa. $6.95

SHAKESPEARE LEXICON AND QUOTATION DICTIONARY, Alexander Schmidt. Full definitions, locations, shades of meaning in every word in plays and poems. More than 50,000 exact quotations. 1,485pp. 6½ x 9¼. 2-vol. set.
Vol. 1: 22726-X Pa. $17.95
Vol. 2: 22727-8 Pa. $17.95

SELECTED POEMS, Emily Dickinson. Over 100 best-known, best-loved poems by one of America's foremost poets, reprinted from authoritative early editions. No comparable edition at this price. Index of first lines. 64pp. 5³⁄₁₆ x 8¼.
26466-1 Pa. $1.00

CELEBRATED CASES OF JUDGE DEE (DEE GOONG AN), translated by Robert van Gulik. Authentic 18th-century Chinese detective novel; Dee and associates solve three interlocked cases. Led to van Gulik's own stories with same characters. Extensive introduction. 9 illustrations. 237pp. 5⅜ x 8½. 23337-5 Pa. $7.95

THE MALLEUS MALEFICARUM OF KRAMER AND SPRENGER, translated by Montague Summers. Full text of most important witchhunter's "bible," used by both Catholics and Protestants. 278pp. 6⅝ x 10. 22802-9 Pa. $12.95

SPANISH STORIES/CUENTOS ESPAÑOLES: A Dual-Language Book, Angel Flores (ed.). Unique format offers 13 great stories in Spanish by Cervantes, Borges, others. Faithful English translations on facing pages. 352pp. 5⅜ x 8½.
25399-6 Pa. $8.95

THE CHICAGO WORLD'S FAIR OF 1893: A Photographic Record, Stanley Appelbaum (ed.). 128 rare photos show 200 buildings, Beaux-Arts architecture, Midway, original Ferris Wheel, Edison's kinetoscope, more. Architectural emphasis; full text. 116pp. 8¼ x 11. 23990-X Pa. $9.95

OLD QUEENS, N.Y., IN EARLY PHOTOGRAPHS, Vincent F. Seyfried and William Asadorian. Over 160 rare photographs of Maspeth, Jamaica, Jackson Heights, and other areas. Vintage views of DeWitt Clinton mansion, 1939 World's Fair and more. Captions. 192pp. 8⅞ x 11. 26358-4 Pa. $12.95

CAPTURED BY THE INDIANS: 15 Firsthand Accounts, 1750-1870, Frederick Drimmer. Astounding true historical accounts of grisly torture, bloody conflicts, relentless pursuits, miraculous escapes and more, by people who lived to tell the tale. 384pp. 5⅜ x 8½. 24901-8 Pa. $8.95

THE WORLD'S GREAT SPEECHES, Lewis Copeland and Lawrence W. Lamm (eds.). Vast collection of 278 speeches of Greeks to 1970. Powerful and effective models; unique look at history. 842pp. 5⅜ x 8½. 20468-5 Pa. $14.95

THE BOOK OF THE SWORD, Sir Richard F. Burton. Great Victorian scholar/adventurer's eloquent, erudite history of the "queen of weapons"—from prehistory to early Roman Empire. Evolution and development of early swords, variations (sabre, broadsword, cutlass, scimitar, etc.), much more. 336pp. 6⅛ x 9¼.
25434-8 Pa. $9.95

AUTOBIOGRAPHY: The Story of My Experiments with Truth, Mohandas K. Gandhi. Boyhood, legal studies, purification, the growth of the Satyagraha (nonviolent protest) movement. Critical, inspiring work of the man responsible for the freedom of India. 480pp. 5⅜ x 8½. (USO) 24593-4 Pa. $8.95

CELTIC MYTHS AND LEGENDS, T. W. Rolleston. Masterful retelling of Irish and Welsh stories and tales. Cuchulain, King Arthur, Deirdre, the Grail, many more. First paperback edition. 58 full-page illustrations. 512pp. 5⅜ x 8½. 26507-2 Pa. $9.95

THE PRINCIPLES OF PSYCHOLOGY, William James. Famous long course complete, unabridged. Stream of thought, time perception, memory, experimental methods; great work decades ahead of its time. 94 figures. 1,391pp. 5⅜ x 8½. 2-vol. set.
Vol. I: 20381-6 Pa. $13.95
Vol. II: 20382-4 Pa. $14.95

THE WORLD AS WILL AND REPRESENTATION, Arthur Schopenhauer. Definitive English translation of Schopenhauer's life work, correcting more than 1,000 errors, omissions in earlier translations. Translated by E. F. J. Payne. Total of 1,269pp. 5⅜ x 8½. 2-vol. set.
Vol. 1: 21761-2 Pa. $12.95
Vol. 2: 21762-0 Pa. $12.95

MAGIC AND MYSTERY IN TIBET, Madame Alexandra David-Neel. Experiences among lamas, magicians, sages, sorcerers, Bonpa wizards. A true psychic discovery. 32 illustrations. 321pp. 5⅜ x 8½. (USO) 22682-4 Pa. $9.95

THE EGYPTIAN BOOK OF THE DEAD, E. A. Wallis Budge. Complete reproduction of Ani's papyrus, finest ever found. Full hieroglyphic text, interlinear transliteration, word-for-word translation, smooth translation. 533pp. 6½ x 9¼.
21866-X Pa. $11.95

MATHEMATICS FOR THE NONMATHEMATICIAN, Morris Kline. Detailed, college-level treatment of mathematics in cultural and historical context, with numerous exercises. Recommended Reading Lists. Tables. Numerous figures. 641pp. 5⅜ x 8½.
24823-2 Pa. $11.95

THEORY OF WING SECTIONS: Including a Summary of Airfoil Data, Ira H. Abbott and A. E. von Doenhoff. Concise compilation of subsonic aerodynamic characteristics of NACA wing sections, plus description of theory. 350pp. of tables. 693pp. 5⅜ x 8½. 60586-8 Pa. $14.95

THE RIME OF THE ANCIENT MARINER, Gustave Doré, S. T. Coleridge. Doré's finest work; 34 plates capture moods, subtleties of poem. Flawless full-size reproductions printed on facing pages with authoritative text of poem. "Beautiful. Simply beautiful."–*Publisher's Weekly.* 77pp. 9¼ x 12. 22305-1 Pa. $7.95

NORTH AMERICAN INDIAN DESIGNS FOR ARTISTS AND CRAFTSPEOPLE, Eva Wilson. Over 360 authentic copyright-free designs adapted from Navajo blankets, Hopi pottery, Sioux buffalo hides, more. Geometrics, symbolic figures, plant and animal motifs, etc. 128pp. 8⅜ x 11. (EUK) 25341-4 Pa. $8.95

SCULPTURE: Principles and Practice, Louis Slobodkin. Step-by-step approach to clay, plaster, metals, stone; classical and modern. 253 drawings, photos. 255pp. 8⅜ x 11.
22960-2 Pa. $11.95

THE INFLUENCE OF SEA POWER UPON HISTORY, 1660–1783, A. T. Mahan. Influential classic of naval history and tactics still used as text in war colleges. First paperback edition. 4 maps. 24 battle plans. 640pp. 5⅜ x 8½. 25509-3 Pa. $14.95

THE STORY OF THE TITANIC AS TOLD BY ITS SURVIVORS, Jack Winocour (ed.). What it was really like. Panic, despair, shocking inefficiency, and a little heroism. More thrilling than any fictional account. 26 illustrations. 320pp. 5⅜ x 8½.
20610-6 Pa. $8.95

FAIRY AND FOLK TALES OF THE IRISH PEASANTRY, William Butler Yeats (ed.). Treasury of 64 tales from the twilight world of Celtic myth and legend: "The Soul Cages," "The Kildare Pooka," "King O'Toole and his Goose," many more. Introduction and Notes by W. B. Yeats. 352pp. 5⅜ x 8½. 26941-8 Pa. $8.95

BUDDHIST MAHAYANA TEXTS, E. B. Cowell and Others (eds.). Superb, accurate translations of basic documents in Mahayana Buddhism, highly important in history of religions. The Buddha-karita of Asvaghosha, Larger Sukhavativyuha, more. 448pp. 5⅜ x 8½. 25552-2 Pa. $12.95

ONE TWO THREE . . . INFINITY: Facts and Speculations of Science, George Gamow. Great physicist's fascinating, readable overview of contemporary science: number theory, relativity, fourth dimension, entropy, genes, atomic structure, much more. 128 illustrations. Index. 352pp. 5⅜ x 8½. 25664-2 Pa. $8.95

ENGINEERING IN HISTORY, Richard Shelton Kirby, et al. Broad, nontechnical survey of history's major technological advances: birth of Greek science, industrial revolution, electricity and applied science, 20th-century automation, much more. 181 illustrations. ". . . excellent . . ."–*Isis.* Bibliography. vii + 530pp. 5⅜ x 8¼.
26412-2 Pa. $14.95

DALÍ ON MODERN ART: The Cuckolds of Antiquated Modern Art, Salvador Dalí. Influential painter skewers modern art and its practitioners. Outrageous evaluations of Picasso, Cézanne, Turner, more. 15 renderings of paintings discussed. 44 calligraphic decorations by Dalí. 96pp. 5⅜ x 8½. (USO) 29220-7 Pa. $4.95

ANTIQUE PLAYING CARDS: A Pictorial History, Henry René D'Allemagne. Over 900 elaborate, decorative images from rare playing cards (14th–20th centuries): Bacchus, death, dancing dogs, hunting scenes, royal coats of arms, players cheating, much more. 96pp. 9¼ x 12¼. 29265-7 Pa. $12.95

MAKING FURNITURE MASTERPIECES: 30 Projects with Measured Drawings, Franklin H. Gottshall. Step-by-step instructions, illustrations for constructing handsome, useful pieces, among them a Sheraton desk, Chippendale chair, Spanish desk, Queen Anne table and a William and Mary dressing mirror. 224pp. 8⅛ x 11¼.
29338-6 Pa. $13.95

THE FOSSIL BOOK: A Record of Prehistoric Life, Patricia V. Rich et al. Profusely illustrated definitive guide covers everything from single-celled organisms and dinosaurs to birds and mammals and the interplay between climate and man. Over 1,500 illustrations. 760pp. 7½ x 10⅛. 29371-8 Pa. $29.95

Prices subject to change without notice.